nowhere in particular
jonathan miller

mitchell beazley

For Rosie and Isobel

Nowhere in Particular
by Jonathan Miller

First published in Great Britain in 1999 by Mitchell Beazley,
an imprint of the Octopus Publishing Group Ltd,
2–4 Heron Quays, London E14 4JB

ISBN 1 84000 150 X

A CIP catalogue record for this book is available from the British Library

Commissioning Editor: Margaret Little
Art Director: Gaye Allen
Design: Chloë Alexander
Production: Rachel Staveley

Typeset in Monotype Grotesque
Printed and bound by Toppan Printing Company in Hong Kong

Acknowledgements

Page 4 Bridgeman Art Library/Louvre, Paris
Page 5 The Tate Gallery, London
Page 6 Teylers Museum, Nederlands
Page 7 National Gallery, London

At their smallest size, the images in this book are exact reproductions
of the original prints. The images have only been cropped where they
appear larger.

nowhere in particular

jonathan miller

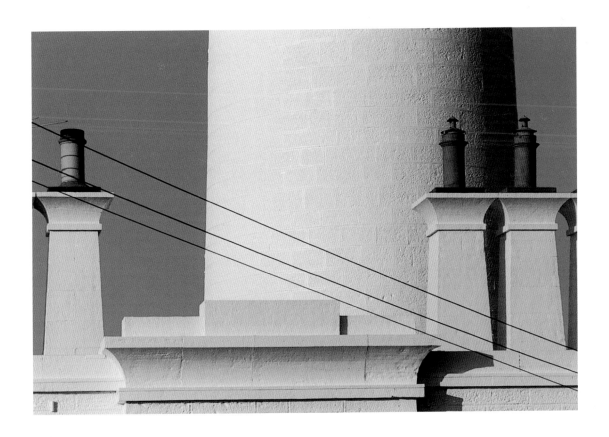

mitchell beazley

Introduction

I N A LECTURE devoted to the achievement of the 17th-century painter Claude, JMW Turner doubted that his French predecessor "could have attained such powers but by the continual study of the parts of nature". He was referring to the sketches in which Claude alluringly records his informal observation of natural detail. And yet as far as Turner was concerned, the idea of dignifying such studies as free-standing works of art was more or less inconceivable, because although he conceded that finished landscapes were, in a sense "pictures made up of bits", he saw no justification for exhibiting "pictures of bits" as such.

The irony is that while Turner himself rarely, if ever, painted what he would have described as a *bit* of a scene, many of his contemporaries did. The fact that such sketches were increasingly rendered in oil indicates that they were produced as an end in themselves and not necessarily with a view to a more "serious" painting imaginatively composed of such bits.

Thirty years before Turner's lecture, the French artist Pierre-Henri de Valenciennes had painted unusually "beheaded" pictures of Roman rooftops in which the normally subsidiary details of chimneys and tiles assumed a monumental significance. At the same time, the previously conventional landscape painter Thomas Jones reframed his own vision and composed a series of disconcertingly eccentric canvasses representing the overlooked and under-valued backs and tops of Neapolitan houses. The serious attention thus given to the negligible aspects of the visible world gathered momentum in the years that followed, and in works from 1820 onward, it is possible to recognise a genre of self-sufficient "pictures of bits". This, as Peter Galassi, curator of photography at New York's Museum of

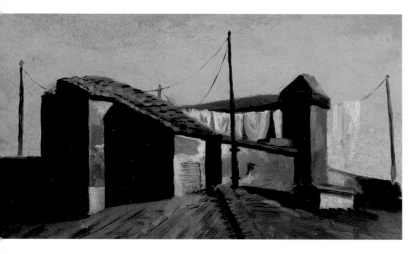

Pierre-Henri de Valenciennes
Roof top in sunlight, Rome
(detail)
c.1782-84

Modern Art, points out, "is true even in the rare cases where the sketch apparently served only to record a motif for a later composition". By panning up to frame the disintegrating eaves of an old barn, John Linnell created a painting that is much more vigorous and memorable than the public painting in which he later included this "trivial" motif. With this exception, none of the oil sketches

which figured in Galassi's 1981 exhibition "Painting before Photography" can be identified as parts of or preliminaries to more important canvasses. On the contrary, they are independent works of art which "take forthrightly as their subject a single, nameable thing: the trunk of a tree, a cloud, a humble gate". As Galassi states in his catalogue, Constable expressed the new mood when he confessed his love for "old rotten banks, slimy posts and brick work".

Turner's antithesis between "pictures of bits" and paintings imperceptibly made up of them has its natural counterpart in vision itself. The reason is that the capacity to resolve fine detail is confined to a surprisingly small area of the retina, the fovea, around which visual acuity falls off so steeply that it's impossible to take in the details of a whole scene at a single glance. Try fixing your eyes on the last word of this sentence and see how difficult it is to read the surrounding text. The result of this restricted acuity is that our perception of the visual world has to be assembled in discrete instalments. Although we are not explicitly aware of doing so, we are constantly flicking our gaze from one part of the visual field to the next, and by bringing the

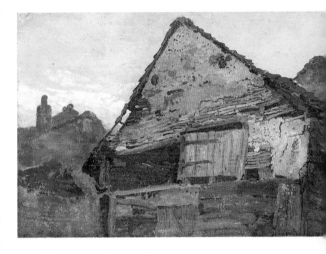

John Linnell
Study of Buildings (detail)
c.1806

specialised centre of the retina to bear on one sector of the scene after another we collect an anthology of sporadic snapshots from which we build up an apparently detailed picture of the world around us. In order to achieve this effect the brain has to overcome at least two representational problems. For one thing, it is necessary to suppress the distractingly smeared imagery which inevitably accompanies rapid eye movements from one fixation point to the next. The method by which the nervous system does this is not fully understood, but one way or another vision is briefly switched off whenever the eye disengages itself and flicks to the next position. To all intents and purposes the subject is conveniently blinded during these potentially disruptive episodes.

Although the efficiency of this mechanism is a necessary condition, it is not enough to guarantee the characteristic coherence of visual experience. In addition to extinguishing the blur that occurs between fixations, the visual system has to integrate the consecutive series of snapshots into an instantaneous panorama. Once again, the mechanism by which the brain achieves this remains almost entirely obscure, but it presupposes the existence of a short-term storage device capable of retaining and logging each shot. Even so, it's difficult to understand how the compilation is implemented and how the discontinuities between adjacent bits are smoothed out. Although the finished picture is unarguably "made up of bits", that's not how we see it. It doesn't look like one of

Hockney's photographic collages; we witness the scene as a continuous whole. It's tempting to visualise this process in terms of a hypothetical work space, something like a studio in which the artist lays out and surveys his informal sketches before putting them together to make up an imaginative landscape. But the analogy is misleading. Apart from the fact that the artist's sketches take some time to "do", the process by which they're elaborated into a formal picture takes even longer, whereas the "bits" with which the brain has to work are recorded in a fraction of a second and the act of composition is just as rapid.

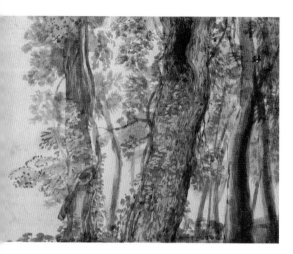

Besides, in contrast to a piece of art work which requires no such thing, it simply gets done and it makes no sense to ask by whom. As the American philosopher Daniel Dennett has argued, we must shake off the idea of a Cartesian viewing theatre to which retinal information is delivered for conscious consideration. If there were such a place, we would have to imagine it occupied by a phantom spectator; once we let that genie out of the lamp, philosophical chaos ensues.

All the same, the physiological peculiarities of human vision have something to do with the relationship between pictorial details and finished pictures. Although it is dangerous to take the comparison literally, it is a helpful way of thinking about the snapshots that are collected in this book.

The photographs which I began taking nearly thirty years ago are unquestionably "pictures of bits", and like the "rotten banks and slimy posts" which delighted Constable, they are negligible things to which one would normally pay no attention at all. Nevertheless, these fragments and details attracted my eye and I felt the irresistible urge to record them. I was unable to draw or paint what I saw, and in any case, I recognised that even if I had had the skill, I preferred a more mechanical method of capturing such appearances – something analogous to the method by which the retina makes its "prints". So, with one or two exceptions, I used a cheap automatic camera that would relieve me of the task of taking light readings and calculating exposures.

What I wanted to do was to choose the view, frame it accurately and let everything else take care of itself. For the same reason I was happy to deliver the film to a 24-hour developing service, secure in the knowledge that the unpredictable variations of commercial processing would introduce peculiarities that I couldn't possibly foresee. For example, in the "Lighthouse" series which follows this introduction, the blue of the sky is much more intense and saturated than the colour I saw through the viewfinder, but in the final outcome I preferred what I got, to the picture I thought I was taking – and from then on I looked forward

to such chemical "accidents". Fidelity was not, after all, the name of the game, though to be honest I am not quite certain what game I *was* playing. It's related in some way to the pictures I mentioned earlier and to the game (if that's the right word) that Thomas Jones was playing when he took such pleasure in the formality of blank walls and sightless windows. But as it happens I didn't come across Thomas Jones until several years after I had started taking these snapshots. And the same goes for most of the other painters who were to be seen in Peter Galassi's show in New York.

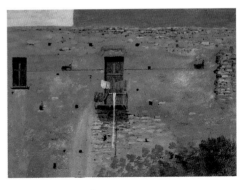

Thomas Jones
A Wall in Naples
c.1782

Anyway, apart from the fact that it would be impudent to compare amateur snapshots with masterly paintings, the photos that are collected in this book are conspicuously less "scenic" than the pictures exhibited by Galassi, all of which, fragmentary though they are, represent a fully three-dimensional world in which the viewpoint of the artist is an intelligible part of the composition. For example, it's easy to tell where De Valenciennes would have been standing when he painted his Roman rooftops, and although the main part of each building is teasingly left out, its supporting presence is forcefully implied.

By contrast, it's difficult to reconstruct the scenes from which my "bits" have been captured. With certain conspicuous exceptions the photos were taken flat on and close up, so that the configuration more or less coincides with the plane of the paper. They're abstract designs derived from real surfaces – assemblages, if you like, in which haphazard wreckage and decay has done most of the art work for me. Even when the arrangement is unmistakably three-dimensional, it's impossible to tell what the immediate surroundings would have looked like – which is what I mean when I say that few of these pictures are even implicitly scenic. They certainly aren't picturesque either. In spite of the fact that there is a recurrent theme of ruin and disarray, once regarded as a distinctive feature of that particular genre, there is too little nature and too much rubbish to satisfy the romantic definition of the picturesque. Like the photographs of Aaron Siskind with which I admiringly recognise an affinity, these are just bits and pieces from nowhere in particular. I can't pretend that they add up to much, but in an odd way that has nothing to do with evocativeness, the collection is more than the sum of its randomly scavenged parts. The notes that I've included were retrieved from a tip of jottings which were accumulated over the same period of time. Like the pictures they represent bits of thought and thoughts about bits, none of them intended for anywhere in particular.

London, 1999

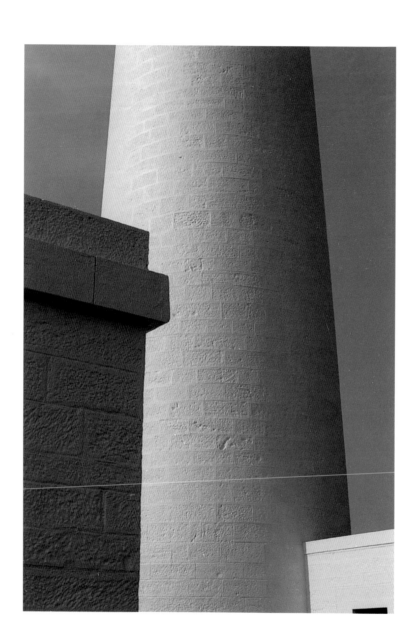

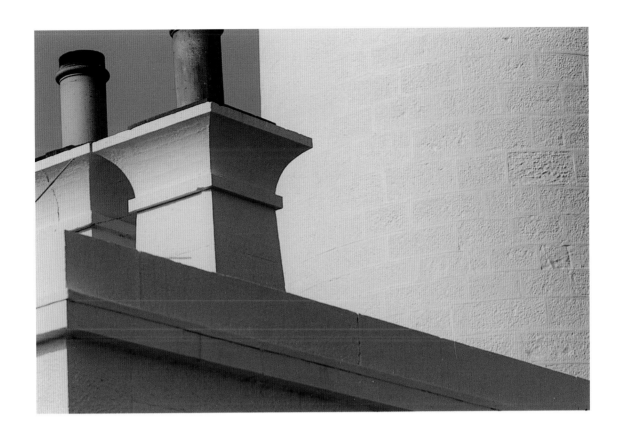

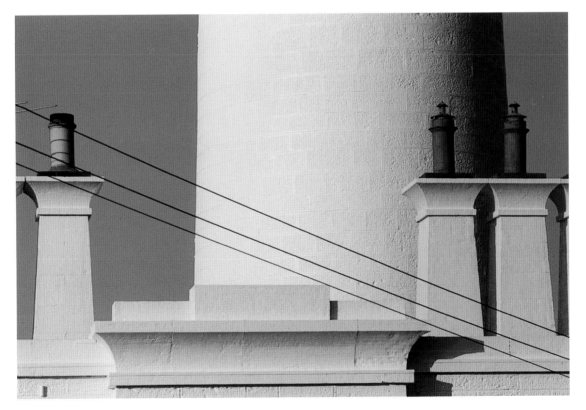

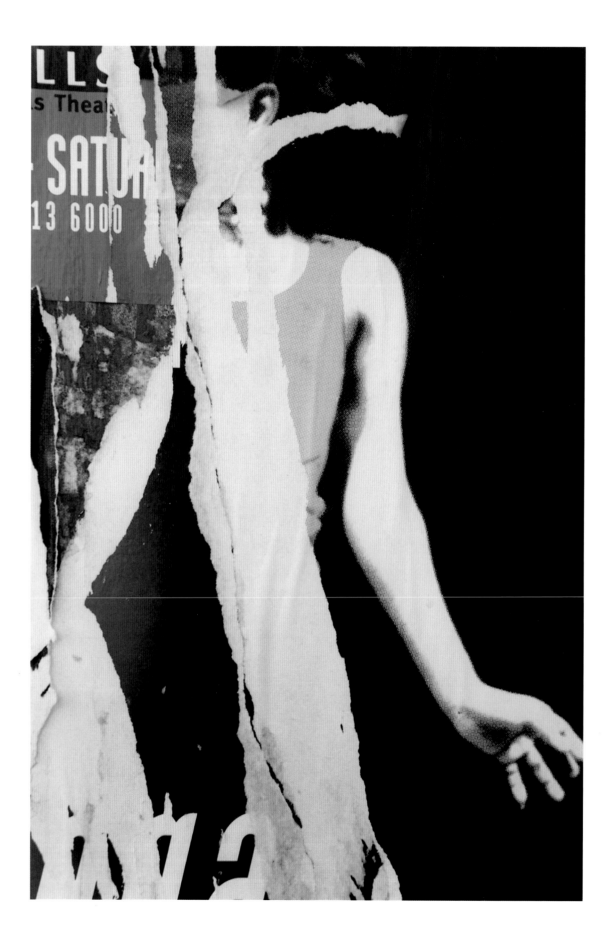

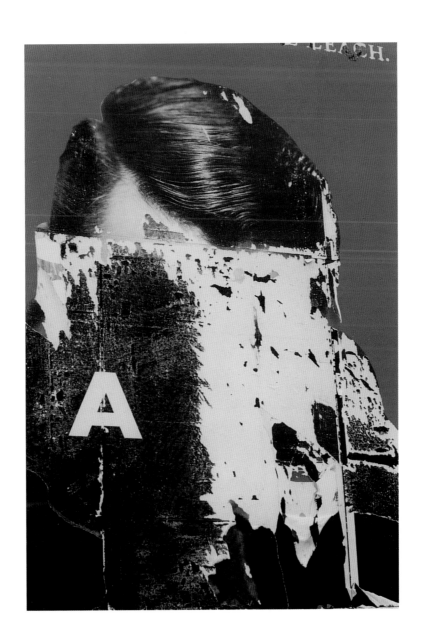

New York to Chicago, November 1963

An empty winter landscape.
Even the cities are deserted, with scuds of snow blowing down passages
behind factories. Flags at half-mast across the whole landscape.
Warehouses, printed chimneys, timber shacks. Piles of rusty oil drums.
Lopez body-shop. Broil-a-foil. Radio antennae thin as hemlock against the
snow. *Cook's Industrial Lubricants. Linden NJ. Sterling extruder.*

Factory ventilators – fan vents – rusty galvanised iron hoods with jointed
pipes. White clapboard estates among the upright pewter machinery of the
winter trees. An ice-bound copse, cold girders set at angles to the old cast-
iron trunks. Twisted, frost-busted wreckage of the neighbourhood dump.

In the fields and on the edges of the woods, streams lie like open blades
half-sheathed in scabbards of aluminium ice.

Darkly silent herds of freight trucks with roofs like the horizontal spines of
stockaded cattle. *Appliance distributors.*

Whitened fields. The snow raked thin and scraped to the furrows.
Harsh, tubular stalks of corn, black and broken in a silhouetted hypotenuse.
Frame-house farms present their wintry constructions – isosceles, trapezoids
and parallelograms in turn as they rotate about the advancing train.

Scrawled in white paint on a tiny rural railway tunnel:
JO MORADISI LIKES IKE.

There is a young army recruit in the compartment. He is much too small for
his huge uniform and his blunt ferret's head pokes from the top of it, as if it
were coming out of a stiff piece of inherited furniture.

The train keeps slowing down. They say there is a large freight wreck up the
line. By the time darkness comes down, the train stops every few minutes as
we approach the wreck. We begin to see bituminous flares set up along the
track. The train draws slowly by the overturned freight cars, like a herd of
cattle dead of foot-and-mouth. Gangs of black railway workers like Masai
hunters dismembering their prey.

January 1964

A walk with Alfred Kazin to the south end of Manhattan and then to Brooklyn. He'd taken off his galoshes by the time I answered his ring at the door and they were lying at his feet like snake casts. We took a cab and roared down the bumpy cobbles of the Westside Highway. A cold Sunday mist, unheated by weekday activity, hung over the silent docks. Past the Cunard sheds, past the Dutch and French lines. A large Israeli liner with blue stars on its funnel – there's something incongruous about a Jewish boat.

Below 14th Street. The green and brick-red timber façades of the Erie and Pennsylvania Railroad sheds. Crudely classical stage proscenia with elegant lettering in faded gold printed across the pediments. Print everywhere – fading in plastery palimpsests on huge side walls of buildings. Hoardings held up by big skeletal scaffolds. Printed roadway signs: arrows and indications.

The taxi took a dip off the highway, down into the long, foggy vaults of the dockside. We got out in the misty, icy silence of Sunday in the city. From somewhere out in the bay came the bronchitic groans of fog-bound shipping. Long, high ravines sheered off on each side; shadowy and darkly silent.

Aztec Deco banks – sooty porticoes – the industrial Palladian of the old Germania building with the date 1865 chiseled, augustly severe and shadowed with grime.

Across the Brooklyn Bridge with K now slightly out of breath with exertion or possibly excitement at the approach of Brooklyn, still invisible. A timber promenade runs down the centre of the bridge, raised above the traffic which howls by on each side. It's like entering a huge cat's cradle of steel as the suspension cables swing up in vertiginous crescents fore and aft. In the middle of the bridge you lose sight of land altogether and you seem to be aboard the *Pequod* with steel shrouds strung from the granite masts.

To the north I can just make out the Manhattan Bridge lightly printed on the blotting-paper of the fog.

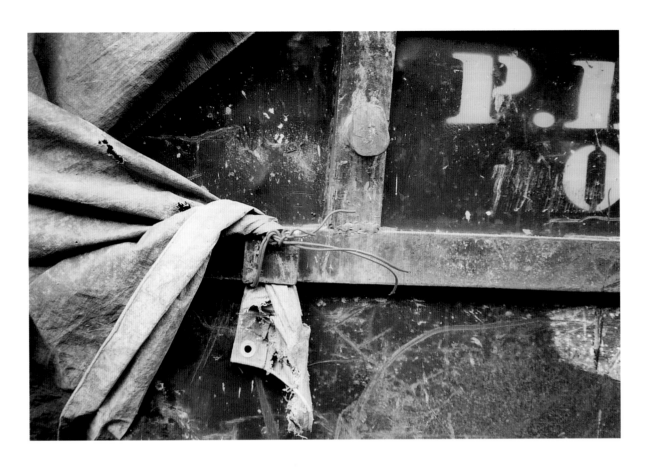

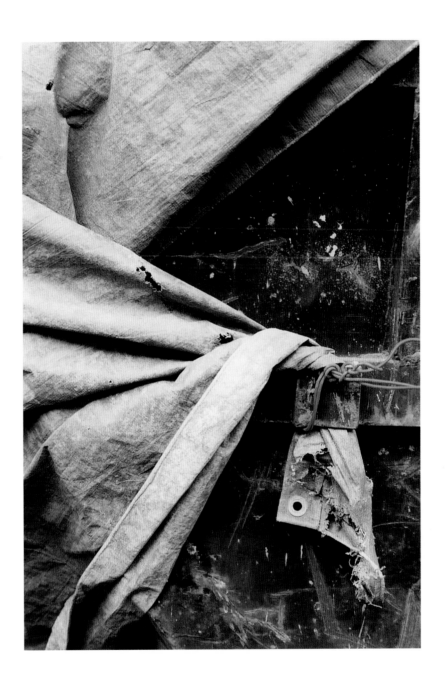

Jane Austen on theatre

I shall always look back on our theatricals with exquisite pleasure. There was such an interest, such an animation, such a spirit diffused. Everybody felt it. We were all alive. There was employment, hope, solicitude, bustle, for every hour of the day. Always some little objection, some little doubt, some little anxiety to be got over. I never was happier.

From *Mansfield Park*

Yes, I suppose so.

Proust on madness

The painter had heard, somewhere, that Vinteuil was threatened with loss of his reason. And he insisted that signs of this could be detected in certain passages in the sonata. This remark did not strike Swann as ridiculous; rather, it puzzled him. For since a purely musical work contains none of those logical sequences the interruption or confusion of which, in spoken or written language, is a proof of insanity, so insanity diagnosed in a sonata seemed to him as mysterious a thing as the insanity of a dog or a horse…

From *A la recherche du temps perdu*

Janacek on conversation

I listen stealthily to the conversation of passers-by, watching their facial expressions, noting the environment of the speaker, the company present, the time, light, dusk, warmth. I find the reflection of all this in the written melody. How many variations have I encountered in the speech melody of one and the same word. Here it was radiant and flexible, there hard and piercing.

From a letter to Max Brod

Associated movements

In the darts matches we see on television these days, you can see that each player displays a characteristic facial twitch at the moment when the dart leaves his hand. A quick raising and lowering of the eyebrows, a rapid dropping of the jaw with the lips closed, an abrupt pursing of the mouth. What's going on? None of these movements have anything to do with helping the dart on its way to the target. This makes me wonder about some of the expressions which pass across the face of a conductor during an orchestral performance. Are they expressive instructions to the orchestra or are they involuntary responses to what the orchestra is playing?

Bernie's baby

She smiles each time I look at her — whatever "looking at her" means. But smiling's not all she does. In some sense it is the least she does. Each time she smiles she raises both arms and rubs the side of her smiling face with her hands, wriggling and twisting her body the while. The whole gesture, of which the smile is a relatively small part, looks like an expression of coy evasion, as if she is embarrassed by the encounter and is doing her best to escape from it.

Perceptions are only formed on the basis of motility and its impulses.
From Paul Schilder's *Image and Appearance of the Human Body*

Directing a play – Robert Lowell's *Old Glory*, July 1964

The actors keep pleading for props and I begin to realise how much physical objects occupy the performer's hands and how much they direct his performance. We seem to be nothing without objects. We're looting the tangible world for artificial limbs – anything will do: pencils, hankies, cups and matchboxes. We are like carnivorous amoebae, gliding about and engulfing things – holding them, warming them and then discarding them before we pass on and take up something else. It is as though our body image was made of protoplasm, pouring itself down our arms and into the objects we handle until, warmed by our touch, they become briefly incorporated.

The James-Lange theory seems to apply to acting. One of the actors asks today what one of the lines means. No one seems to know – until he just says it and finds out by doing so. Meaning is often locked up in the performance – or rather performance unlocks the meaning. Actors sometimes won't say a line until they know for certain what it means. It's sometimes necessary to persuade them to just say it. It's as if performance is the Prince Charming kiss with which the actor stirs the sleeping line into existence.

The importance of trivial half-conscious movements in a performance. I bring a quotation from *The Rise of Silas Lapham* into rehearsal. The shyness of one of the characters is epitomised by her absent-minded poking of a wood shaving with the point of her parasol. As she comes to the conclusion of a line of thought, "She gave the shaving a little toss from her and took the parasol up across her lap."

N.B.

At Kazin's suggestion I read Dreiser's *American Tragedy*. A strange pre-occupation with the chemistry of human affinities and attractions. Where did he pick up all this stuff about hormones?

Clyde Griffiths, one of a number of boys on the way up. Felix Krull, Julien Sorel and Pip.

The health of the eye seems to demand an horizon. We are never tired so long as we can see far enough.

From Ralph Waldo Emerson's "Nature"

Sunday in the park (circa 1965)

The hawthorn trees are covered in blossom, sprouting inflorescences of eyes. A branched, attentive periscope.

A man with his eyes closed in a deck chair. His head is turned to one side and as we pass unseen next to him I can just make out the blunt pulse of his carotid pumping dreams into his head, but not a drop of the dream leaks out of him.

Out of the park and into the zoo. The gazelle and antelope house. The animals in these fragrant stalls have all the sacerdotal dignity of their ancient role as victims. Watchful and jumpy, with large eyes permanently darkened with fear. Across the way, carefully separated from their traditional prey, are the lions: relaxed, arrogant and mangily superior. They lie on their shelves, one foreleg thrust out, bent indolently at the wrist.

Actions

Vis-à-vis Wittgenstein's question about the difference between my arm going up and my lifting it. Is the difference something mysteriously added to my arm *merely* going up? Is it my doing something – *x,* say – which then *causes* my arm to rise? And is this prior event *x* something which might happen *without* it causing my arm to rise?

Think about the factors which might prevent arm-rise:
1 a heavy weight in the hand;
2 the arm bound to the side;
3 severed tendons in the shoulder;
4 severed motor nerves to the shoulder muscles;
5 spinal transection;
6 an injury to the motor cortex.

With **1** and **2**, the event *x,* which supposedly precedes and causes my arm rising increases as a result of the frustration caused by my failing to raise my arm. In the case of **1** – the heavy weight case – arm-rise might eventually take place as a result of increasing the intensity of *x*. In the second case, I'd say, "Try as I might, I was unable to get my arm to go up". But it would be wrong to say that *x – ie,* my trying – had increased without anything happening. On the contrary, a great deal has happened but none of it has had any effect on arm-raising. A great deal of effort happens, much more than is needed for unimpeded arm-lifting. In this particular case, trying and failing is not the experience of doing *x* (whatever that is) and discovering that nothing happens, but rather of having to exert more mechanical effort than one would expect to under normal circumstances and then finding that the required result doesn't happen. And yet, that is not quite it. Failing to get one's arm to go up in cases **1** and **2** is not a question of doing *x*, then 2 times *x* and finding to one's horror that the arm fails to go up. The trying is somehow part of the failing. In fact, I don't feel tempted to use the word *try* unless some sort of failure happens.

I don't *try* to lift my unimpeded arm; I just lift it. So failing to raise my arm and failing to raise my heavily weighted arm are two entirely different things. Failure to raise my weighted arm is a case of failing to raise a weight. The point is that unless I am mysteriously ignorant of the fact that my arm has been surreptitiously weighted – in my sleep, say – raising my weighted arm is always a case of lifting a weight and not of lifting the arm plus a weight.

Air miles

Striding along the moving walkway at Frankfurt airport I get the enigmatic impression of weightlessness. Presumably this is because the speed at which visual images stream across my retina is much greater than it would be than if I were walking unaided. It's as if one weighs oneself by comparing the muscular effort that one puts into an action with the visual displacement that results.

A game of snap

The game of snap requires the player to react to two identical formats or pictures. How about this variant? Instead of having *identical* pairs you might have the following similar types of pairs:

1 a photograph of something – a cow, say – versus a line drawing of it seen from the same angle and the same size;

2 a photograph of something from one angle and a photograph of it on the same scale but from a different viewpoint;

3 a photograph of something – a bottle, say – versus a photograph which though different belongs to the same category – a flask, say;

4 a photograph of something versus a heavily degraded but otherwise identical photograph of the same thing.

Naming

Naming something from a description of it.
Naming something from a picture of it.
Naming something as a result of feeling it.
Naming something as a result of hearing it.

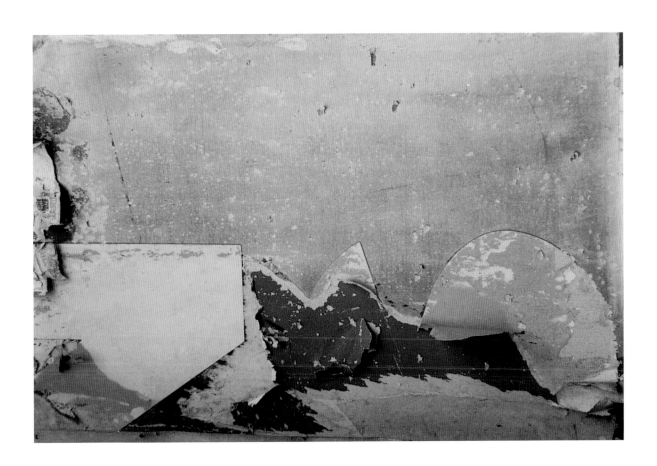

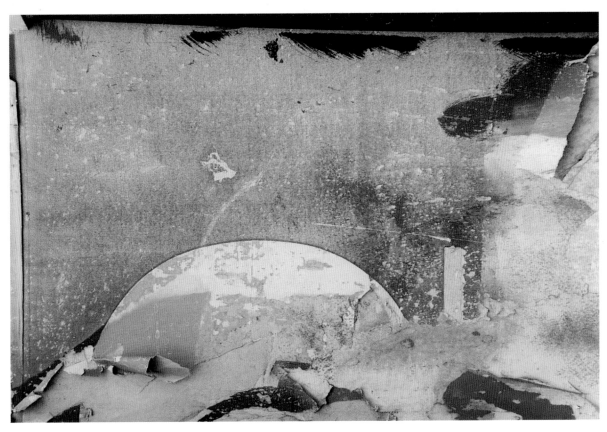

The green umbrella

The story of a performer blocked or frustrated until given some prop or even mannerism is part of theatrical folklore, but unlike most of the other hearsays and myths of the theatre, the story of the green umbrella has more than a grain of truth in it. Again and again one sees actors released and enabled by a prop. This works in one of two ways:

1 having such an object in his hands leads him to do what people normally do with such an object, and then one thing leads to another, in which the completion of one action with the object inevitably sets the stage for the next action;

2 apart from the train of actions which are naturally suggested by having this or that object in his hands, there are metaphorical implications. I give someone a handbag and ask her to clutch it tightly with both hands, which makes her into the sort of person who would turn out to do other things, tempermentally related to handbag-gripping.

Pictures

Distinguish between
1 something being a *picture* of x – a lady, say – as opposed to it being a mere index or conventional sign; such as ♀ on a toilet door.

2 something being a picture of x – a man, say – as opposed to its being a picture of y – a woman or a mustard pot.

3 something being a picture of x as opposed to its being x in person, as it were.

The present tense

Why is it that the present tense is used in the narrative summaries at the beginning of chapters in 19th-century novels, whereas the narration itself uses the past tense? Presumably it's because the chapter in which the narrated events occur has a current existence: that is to say, the summary or synopsis points out the receptacle or container in which the narrated events have a present existence. A counterpart to this summarising present occurs in the description of the contents of a picture: "In the picture, Jesus goes into the wilderness where he is tempted by a devil." So, although Jesus actually *went* into the wilderness, in the pictorial representation he is currently doing so. We also say "what happens in *Hamlet*" and not "what happened in *Hamlet*". What about the present tense of stage directions? "Konstantin goes to his desk, opens the drawers, and looks through his papers." Whereas in the account of an actual production one would probably say: "Konstantin went ever so slowly over to his desk and reluctantly looked at his papers." Perhaps one might even mention the name of the actor who played it that way, since it was his performance which distinguished the action from the one that customarily happens when Konstantin goes over to his desk, etc, etc.

Mental states

We talk about beliefs, wishes, hopes, etc. Are we to assume that these words refer to determinate, numerable states of mind and that for each one of them there is something distinctive which differentiates it from all the other ones, and that there is a series of brain states to which each of these mental states corresponds? Can that be so?

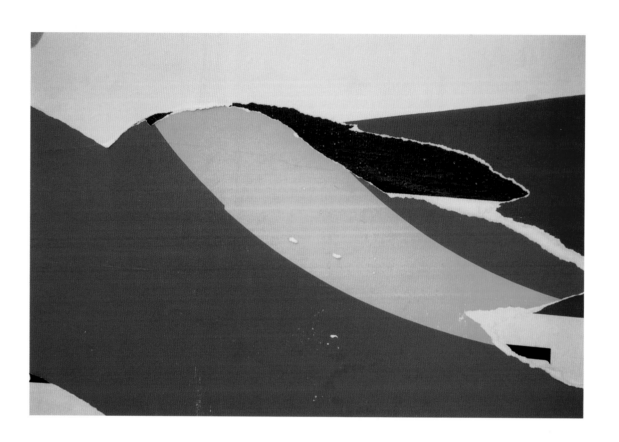

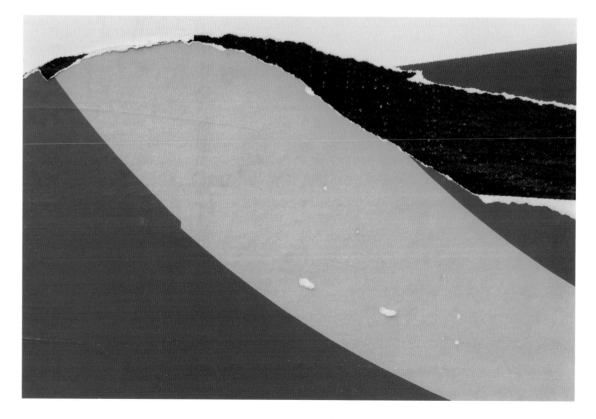

Social constructions

Positive: promotion, baptism, confirmation, qualification, enrollment, registration, initiation, coronation, ordination.
Negative: disqualification, demotion, disbarring, defrocking, abdication, unconditional surrender, conviction, resignation, sacking.
Compare these with: solution, crystallisation, fracture, freezing, melting, evaporation, germination, fertilisation, metamorphosis (insect).

Seeing as

When I talk about seeing something as something else – say, seeing a cloud as a weasel – it's only because I recognise that the thing at which I am looking has an official identity and that any other way of seeing it is in some sense at least a misidentification. But that doesn't mean that I am taken in by the misidentification. Thus, when Polonius agrees with Hamlet that the cloud is backed like a whale, he takes it for granted that Hamlet will not assume that he, Polonius, mistakes it for a whale. So how about Picasso's sculpture in the Minneapolis Art Institute in which the head of a baboon is represented by a battered racing car?

Animal language

One of the reasons why the bee's dance is *not* a language is that its configuration is indivisibly mapped onto the situation which it represents. It's difficult to imagine the bee offering to dance its meaning in a somewhat different way. In other words – something, incidentally, which the bee couldn't even conceive of – there is no such thing as a paraphrase of any particular dance.

Apes and men

In the *Jungle Book*, which he published in the same year as Gustave le Bon's treatise on *The Crowd*, Kipling describes the fickle impulsive apes who occupied the ruined buildings of an extinct aristocratic civilisation:

> *They would sit in circles in the hall of the king's council chamber scratching for fleas and pretending to be men; they would run in and out of the roofless houses and collect pieces of plaster and old bricks in a corner and forget where they had hidden them and fight and cry in shuffling crowds, then break off to play up and down the terraces of the king's garden. They explored all the passages in the palace and the hundreds of little rooms, but they never remembered what they had seen and what they had not. They drank at the tanks, made the water muddy and then they fought over it and then they would all rush together in mobs.*

It's unlikely that Le Bon knew anything about Kipling or vice versa, but the fact that the two authors, writing in the same year, virtually paraphrase one another is a coincidence that requires an explanation.

Although the *Jungle Book* is fondly regarded as a harmless tale of forest folk, it is easy to recognise its hidden agenda and that Kipling's disparaging account of the Bandarlog is prompted by political sentiments similar to the ones which led Le Bon to write so contemptuously about the human crowd. Le Bon would have approved of Kipling's choice of apes to epitomise social behaviour of this sort. As an evolutionist, he recognised the primate ancestry of the human species, and since he regarded the crowd as an evolutionary throwback, representing it as a pack of monkeys would have struck him as a biological truth rather than a literary metaphor. He regarded the members of a crowd as pathetic impersonations of men, brought to this regrettable condition by egalitarian ideas inherited from the revolutions of the 19th century.

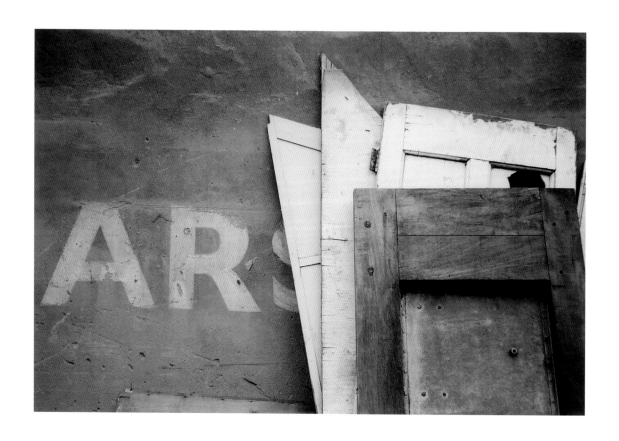
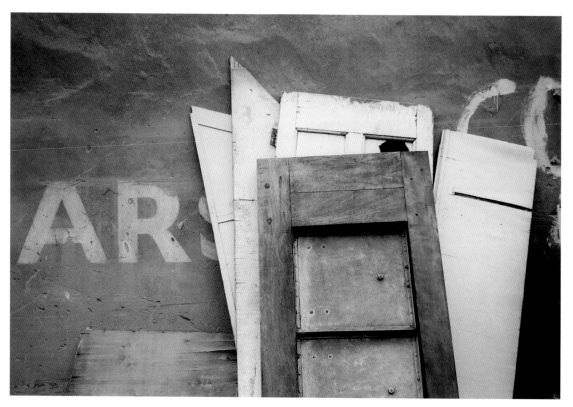

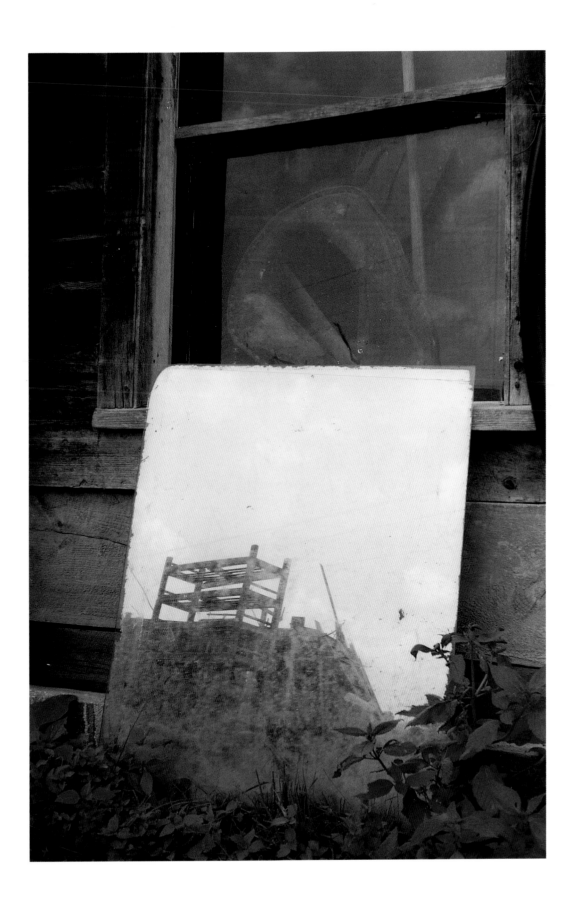

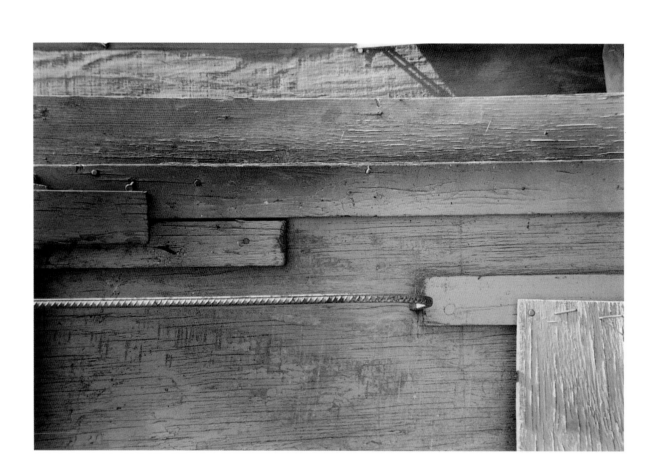

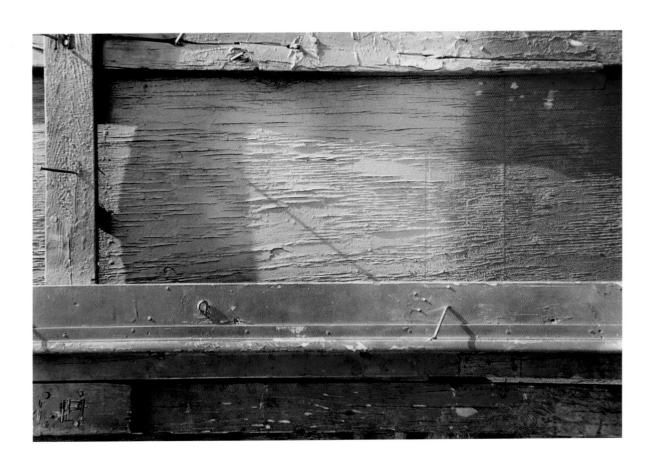

Crack

Hearing the drug "crack" mentioned on the radio the other day reminds me how complicated the semantic field of one word can be. The word *crack* has as its primary focus a particular sort of break in a surface – one which leaves the broken edges in juxtaposition. But then there is the process which led to that state of affairs – *ie*, it's cracked, so that we can therefore have a loud crack as well as a long one. And these are mutually exclusive: you can have a long crack in the ceiling but it's impossible to imagine a long rifle crack.

Associated with the acoustic onomatopœic connotations of the word there are the metaphorical implications of any abruptly stimulating sensation – which is presumably how the drug gets the name *crack*, not to mention the distinctively witty gossip you can hear in a Belfast pub.

But even within the purely mechanical domain, the word *crack* can have different emphases. For example, the surface or substance can be the focus or the theme – *eg,* there was a crack in the glaze. Or the pot was cracked. But the interruption itself can be the theme, thus: "We fished it *out* of the crack." "It was lodged *in* the crack." "She pushed a bristle *through* the crack."

Architecture and pictures

In the Menil Collection in Houston, Texas, the Twomblys and the Barnett Newmans owe some of their impressive appearance to the architectural setting in which they are displayed. You have to take the whole vista into consideration: the huge white walls of the gallery and the deep rectangular returns of the openings through which a painting is glimpsed along with others, half revealed. It's difficult to overestimate the extent to which one is beguiled by the scene of which the paintings are a part.

Actions

I can't clench my fist without contracting the flexor muscles in my forearm.
But would I really want to say that the contraction of my forearm muscles
was the cause of my fist clenching? The thing is that *causes* come before
the events that they bring about, but my fist clenches at the same time as my
forearm muscles contract. Besides, I don't *get* my fist to clench by
contracting my forearm muscles. On the contrary, the only way in which I
can get my forearm muscles to contract is to make a fist with my hand.
So the two are not related to one another as cause and effect. Contracting
my forearm muscles isn't something I have to do first and then, God willing,
my fist clenches! This is not very helpful!

Another way of looking at it: I don't seem to be able to move any of
my muscles as a basic action. A given muscle, my biceps say, can be moved
or contracted by making a gesture which requires the contraction of that
muscle, so that, although the muscle's contraction is unarguably a necessary
component of a particular action, its contraction is not part of what one does
in performing the action. To move my muscles *as* muscles, I have to do
something else, I have to *act* in such a way that certain muscles are bound
to contract in order to achieve the result I am aiming at.

Radio astronomy

In the hot, midsummer fields outside Cambridge, planted among the
buttercups and the ox-eye daisies are two mechanical dishes tilted at the
empty sky – silently attending to events infinitely distant from and totally
different to the comfortable buzzing going on in the meadow.

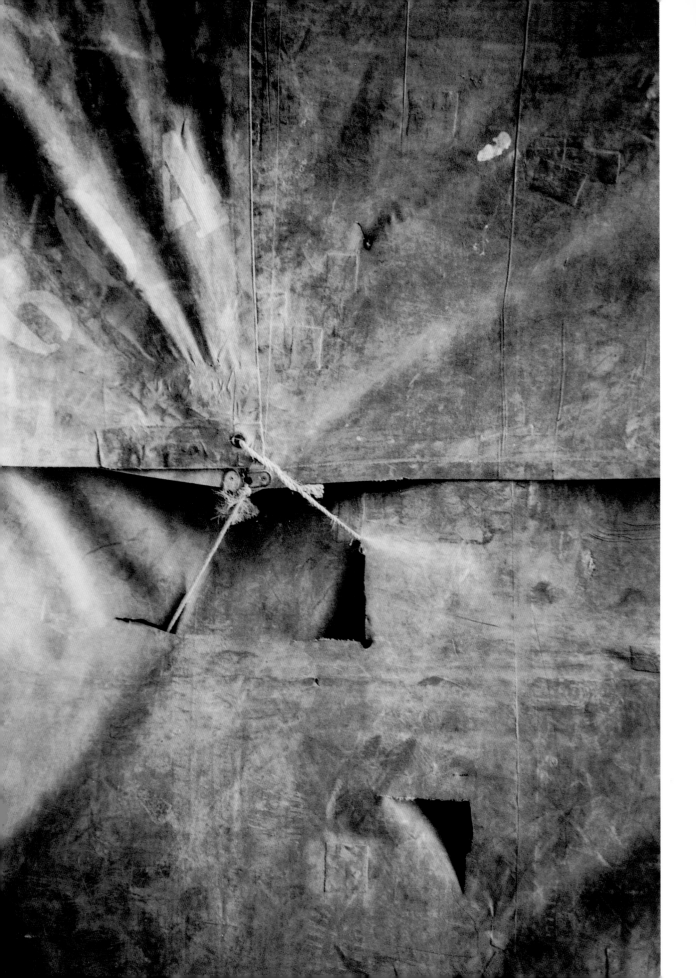

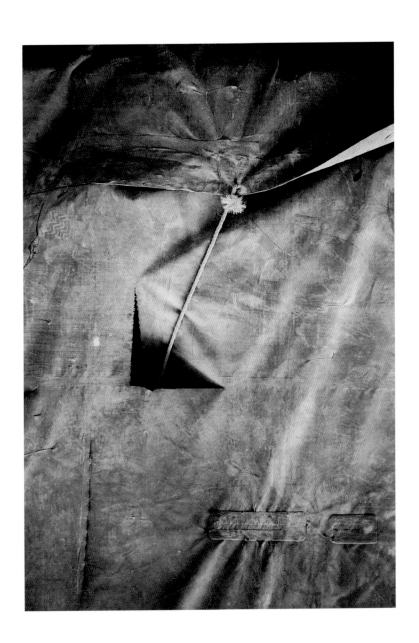

What are you looking at?

Surely there are two possible answers to this question. One answer is, whatever it is that intercepts my eye-line. Someone other than I could just as easily answer this question by simply tracing (in the geometrical sense) the line of my conjugate gaze to the first thing it encounters. There might be some errors here, in that a few degrees could make all the difference between my looking at that barn on the horizon and my seeming to look at the house just to the left of it. All the same, it is a question that can usually be settled by pointing along the line of my gaze, in the hope that my extended arm and finger will pick out what I am looking at better than my mere look would do.

But there is also a sense in which the question "What am I looking at?" cannot be answered either by taking my eye-line into consideration or by my pointing. What if I say, "I am looking at the most beautiful picture in the Uffizi"? Now, as it happens I am standing right in front of Simone Martini's *Annunciation*, and there is no doubt that the large oblong picture that bears that name is the object at which my gaze is directed. But my companion, whose eye-line is directed at the same picture, might not agree that she was looking at the most beautiful picture in the Uffizi.

So how about a somewhat less contentious claim? I might say, "What I am looking at is its style." In this sense of "looking", I am looking at an "aspect" of the picture, something about it that cannot be distinguished simply by following my eye-line.

Traces

The authority of a photograph has something to do with the fact that its appearance is directly caused by whatever it happens to be a picture of, so that as Susan Sontag says, the faintest and most blurred snapshot of Shakespeare would be more interesting than a potrait by Holbein. I can still recall the delightful shock of seeing the indentation of Michaelangelo's hand in what was once the wet, yielding plaster of the Sistine Chapel ceiling. More interesting than his painting of the hand of God.

Advice about shadows

Having failed miserably to represent the shading in a group of objects arranged on a table, I am advised to look at the scene through the fine metal mesh of a tea strainer, and try to focus not on the scene itself but on the mesh. Interesting! The scene is slightly blurred so that shadows appear in relatively simple blocks and you are not plagued by innumerable details of shading.

More about shadows

In a chance encounter with some amateur German painters, Renoir pointed out that the shadows that they represented were invariably much too dark, that no shadow is black but always has a colour. So why does the amateur painter so often get it wrong? It must mean that they have reasons for thinking that shadows are black and that this overwhelms the visual evidence to the contrary. So where do we get the belief that shadows are black? It has something to do with the influence of language. Language makes a distinction between light and dark and (derivatively) between black and white, so that in viewing a scene in which some parts of it are lit and the other parts are in shadow, the amateur artist is biased in favour of blackening the apparently unlit areas.

Identifying colours

In the *Elements of Drawing,* Ruskin points out the difficulty of naming the colours that appear in a good painting:

> *You thought it was brown, presently you feel that is red; next there is, somehow, yellow in it… If you try to copy it you will always find your colour too warm or too cold – no colour in the box will seem to have an affinity with it.*

You could say it was the paint-box that created the problem of finding the right colour; with its fixed set of named colours, it gives the misleading impression that these are the hues that occur in the natural world. In this sense, the paint-box is not unlike a dictionary that lists (or seems to list) the colours that are to be seen. In other words, paint-boxes and dictionaries compromise our ability to see the actual colours of Nature itself.

Seeing *as* and seeing *in*

When he discusses representation, Richard Wollheim talks about seeing the depicted object *in* the paint – meaning presumably that we recognise that it's *apples* which are thus depicted and that it is nevertheless a *depiction* of them. Recognising them as a depiction implies that we acknowledge that someone, *ie* the artist, intended us to recognise that that is what he intended when he made the picture – because we can recognise things in something where there is no such intention. We can "see" an image of the Virgin in the discoloured heartwood of an apple tree, or we may perceive the silhouette of a city in the polished cross section of a piece of variegated agate. In contrast to depictions, we simply marvel at the accidental likenesses, and if we are Hapsburg Archdukes we keep such specimens in our *Schatzkammer*.

When I mistake someone for someone else, once I learn the truth I suddenly see the extent to which he is *unlike* whoever it was I took him for. But I am not tempted to call the original experience an illusion. I can see how I made the mistake, and my subsequent seeings are no longer mistaken. Compare this to illusions which lead me to see things which I have good reason to believe are not in fact what they seem to be – but the illusion persists nevertheless. For example, when I go to the cinema I am fully aware of the fact that I am confronted by a sequence of still pictures alternating with extremely rapid periods of darkness. But I can recite this fact to myself without being able to escape the experience of moving pictures.

Shadows

Flying across the channel above the scattered clouds, I can see the connection between each cloud and its purple shadow on the blue water below. Do I really see, or do I just infer, the fluted shaft of darkness which connects each cloud to its purple image skimming the distant surface of the water?

Reflections

As we fly over the flat fields near Bologna, the lakes and ponds reflect, or I suppose they reflect, the cloudy sky above the aircraft. I say *suppose*, because it's only in the belief that these gaps in the textured fields are reflecting something from somewhere else that I credit the otherwise invisible surface with a glassy sheen. For some reason I see the clouds *in* rather than *on* the surface of these lacunae and I automatically see the surface as something optically different from the matte furrows all around.

With an effort – whatever that means – I can see the fleecy images of the reflected clouds not as virtual images in some virtual depth, way below the level of the fields, but simply as blue and white patches coplanar with the surface of the fields.

Visual information

The amount of significant information that has to be put into a painting is less than one might suppose. In "doing" faces, for instance, you might think that each millimetre requires a distinctive change of shading or colour in order to show the modelling, and as an amateur you're baffled by the technical subtlety that this seems to demand. But when you come to think about it, the problem is rather different. What you have to do is to make decisive changes in shading or colour at certain crucial points, and let the spectator's imagination fill in the intervening gradients. I always imagined that the left cheek of Botticelli's Venus was modelled with infinitesimally small changes of shading, but this turns out to be an illusion. In fact, if you mask out the sharp edge of the cheek, the steep gradients of the nostril and the eye sockets so that all you see is the broad expanse of the cheek itself, it becomes surprisingly apparent that there's no visual modelling whatsoever. Over a space of about ten to 12 square centimetres the colour of the paint is more or less uniform, and yet as soon as you unmask the rest of the face, the cheek appears to be modelled once again.

More about seeing in

Wollheim talks about seeing apples *in* the paintwork (as opposed to the traditional expression of seeing the paintwork *as* apples). It may seem obvious and trivial but there are all sorts of "seeings in" and it would be nice to be clear about the differences.

1 Seeing apples *in* the foliage. In this situation the identity of real apples is compromised by the fact that the otherwise unambiguous contours of the fruit are occluded by the overlapping contours of equally real leaves. But when I see apples *in* the paint, the brushwork isn't something which gets in the way of my seeing the apples more clearly.

2 Seeing something in a container. Apples *in* a bowl or *in* a box or indeed *in* a bowl *in* a room.

3 Seeing faces in leaves, in clouds or in the dying embers of a fire. This is not an example of mistaken seeing, because I know perfectly well that I am looking at whatever it is I am looking at. What I see, rather, is another *aspect*. What about seeing leaves in a forest or embers in a dying fire? That's what forests and dying fires consist of, dammit! It's just that something about the configuration of the leaves, clouds or embers *lends* itself to the perception of another aspect.

4 How about seeing something in a completely cloudless blue sky, when there is nothing which could even begin to lend itself to the seeing in question? This is a free-standing visual experience which owes none of its properties to anything that is actually to be seen. "Why do you bend your eye on vacancy?"

5 All right, back to seeing apples *in* a painting. In the case of real apples, everything about them is a property of the apples themselves and there is nothing left over to contradict this. Whereas in the case of the painted apples, only certain visual features of the configuration lend themselves to the impression. There is an awful lot of paint around, for example. The reason why we talk about seeing apples *in* such a set-up is that not all of it lends itself to apple appearances. On the other hand, you wouldn't want to call this

experience an illusion. When I recognise and see apples in a painting, it's not a question of my supplying the fruity details which the painting somehow leaves out, nor is it a question of my suppressing the pigmenty details which the painting cannot eliminate. As Wollheim rightly stresses, I see it all in all, apples and paint inseparable.

When I look at one of Cezanne's apple paintings and recognise apples *in* it, I would be very offended if someone said that I was just "seeing things". It's certainly not an hallucination. After all, other people see the apples, too, and you wouldn't want to call this a mass hallucination – the Apples of Mons. But nor is it an illusion. In the case of an apple painting what I am seeing is sufficiently like real apples to trigger apple recognition – or to be more accurate, an apple-painting recognition.

The situation is not altogether different from the one in which I say, "I can see his mother in his face." When I say something like this, I obviously don't mean to imply that I can see something other than his face in his face, in the way that I see a tiger looking through the foliage. It's just that I am struck by certain aspects of *his* face which resemble certain aspects of his *mother's* face. Where else but in his face would I expect to find such features?

Words and pictures

Experimental psychologists have shown that their subjects' ability to recall items mentioned in a passage of descriptive prose is made easier by showing them a picture of the situation – an illustration which explains "what's going on". Presumably the converse applies: the memory of a picture might be made easier by the subjects being allowed to hear the reading of the story that the picture illustrates.

Reproduction

I must get some new spectacles to replace the ones I broke last week. What does that mean exactly? I want to reproduce the ones I broke. But that doesn't mean that I want them to be held together with a paper-clip like my old ones were. What I need, obviously, is spectacles that will let me see in the way that the broken pair once did.

So how do we go about that? One method might be to copy the old ones – *ie,* to measure the size and curvature of the lenses, grind new glasses to those specifications and set them in frames of the original design. Such a replacement would automatically meet the needs of my eyes, since that is what the original glasses were prescribed to do. The alternative method is to get the optician to prepare some glasses to the refractive specifications recorded from the original consultation. In other words, it isn't a question of copying the object as such, but of reproducing the functional intention of the original object.

An alternative replacement might be found by sorting through a box of second-hand spectacles and trying them one by one until I found a pair through which I could read small print. Hermit-crab optics. So how about biological optics, then? Each of us grows eyes which, with considerable variations, meet normal visual needs. These eyes are indistinguishable, both in design and in visual function from the ones which were grown by the previous generation and by the generations before. Copies? In one sense they are. But the process by which the eyes of one generation get to be like the eyes of the preceding generation is not one of copying. Genetic instructions are followed and in each generation a satisfactory pair of eyes is the inevitable result. The previous pair of eyes plays no role in either the structure or function of the subsequent pair.

In neither case do the eyes shape themselves according to the refractive requirements of their particular owners. They may be better or worse as eyes – after all, some people have to wear spectacles and others don't – but they are all examples of eyes. But they are neither copied nor prescribed as such.

Novels into films

There are many reasons why good novels won't "go" into films. One of these is the delicate relationship of dialogue to narrative prose. The narration is not simply a disposable support for what would otherwise be dramatic dialogue. In any serious work of fiction the narration and the conversation are inseparably reciprocal. If, in narrating a scene, an author abstains from direct speech in favour of a reported summary of it, this must be what was meant; once you try to film the scene in question, inventing the dialogue which is merely suggested in the text, the fictional artwork is irreversibly deformed.

A character in a novel is not *in it* in the way that someone real might be *in Birmingham* or *in a cubicle*. He can't be taken out of the book, as some people suppose, and put into a film since he is made out of the same sort of material as the book he is in. Mr Carker, for example, is undoubtedly a peculiar individual. Perhaps his most interesting peculiarity is the fact that he is in *Dombey and Son* and can't get out of it.

When TV or film versions of novels "fail", the "failure" is often attributed to the contradiction between the creations of the director and the images which the novel has conjured up in the mind's eye of the individual reader – "that's not how I see Mr Rochester". But there is more to it than that. The experience of reading a novel more or less precludes a filmic version of what it represents. And yet, on the face of it, the idea of a filmed version seems to have every possible advantage. Words, after all, often fail to convey the full details of a scene. For example, it's difficult and usually impossible to recognise someone from a verbal description – unless of course there is some dramatically distinguishing mark such as a scar, Cyrano's nose, etc, whereas even a bad photograph will serve to pick someone out of a crowd. So one might expect a film to fill in all the things that the novelist's words fail to convey. But that misses the point, because a novel is not something which makes the best of a bad job as far as visual representation is concerned, *ie*, with lots of stuff missing that a film version could fill in. In a good novel what the author *gives* is what there *is*. The text somehow fills the fictional space

created by the novelist, and if the reader has read the text properly, he or she would find it difficult to identify the gaps. In other words, in an important work of fiction the text doesn't even admit the possibility of further details. For example: when Conrad describes the governess in *Chance*, he alludes to her hair and its greyness and not much else. On the other hand, this does not mean that the reader necessarily supplies what Conrad has left out. She somehow seems to be complete as described and the shock of seeing her realised in a film is not that of seeing one's own visualisation contradicted by someone else's, but rather of seeing the described depicted.

It's often said that the difficulty of portraying a well-known character from literature on the screen is that each reader has his own mental image of that character. But that's not really the problem. It's not that any one particular realisation is bound to fall short of so many different imaginings, but that no realisation can possibly match an imagining. That's because mental images are a different sort of thing altogether. For one thing, they can have lots of missing parts without seeming to lack them.

Glow

What makes me say that something is *glowing*? How does a glowing patch differ from one which is merely bright? Something might seem to be glowing if its brightness is disproportionately greater than the brightness of its surroundings. A bright-red patch in the darkness glows because something as bright as that in an environment which is otherwise dark must be emitting its own light. The notion of glow also seems to require, though not necessarily, a translucent halo immediately around the patch in question. This also seems to indicate that the coloured patch is a source of light and not just a reflection of it. Glowing patches usually give some visible sign of there being a hotter centre – *ie*, there is a gradient of luminosity and hue – a pale centre shading off to an orange or dull-red periphery.

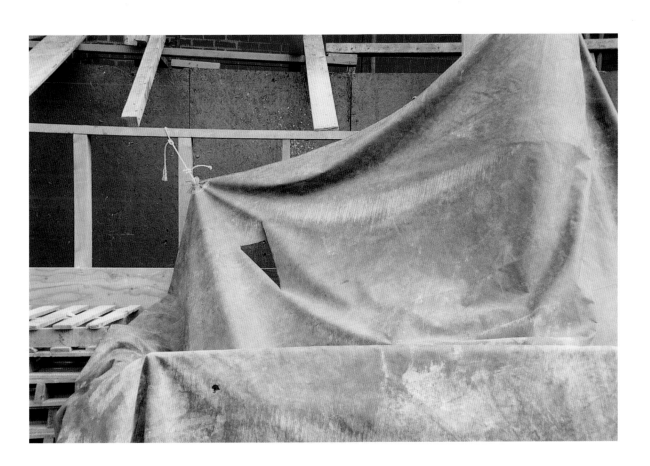

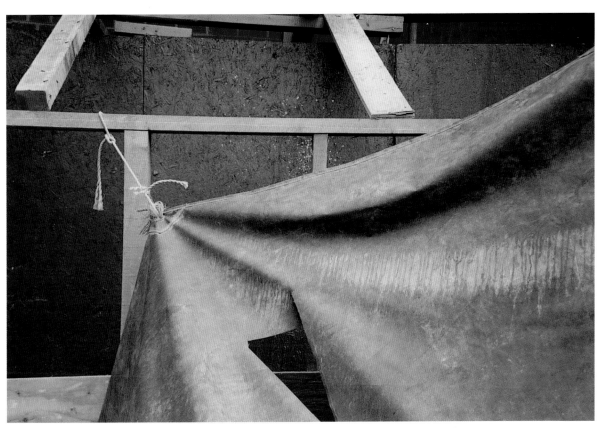

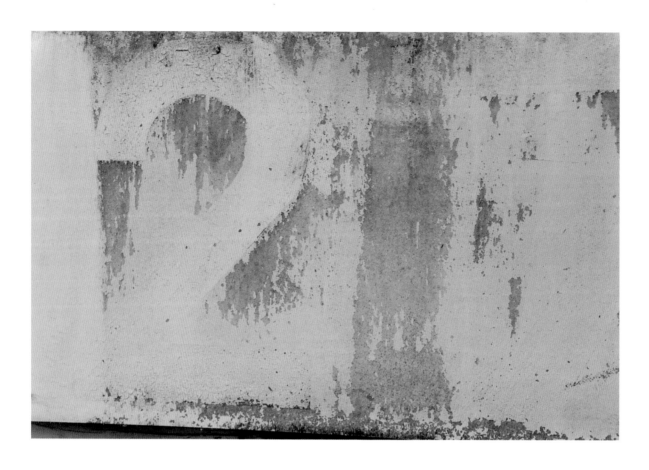

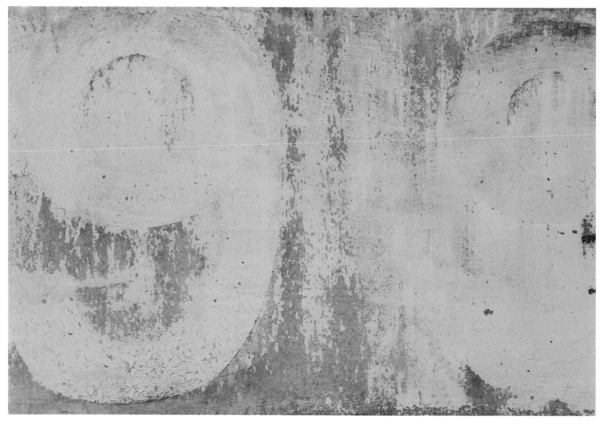

Attention

I am listening to the radio in bed this morning, hearing every word that is spoken. Suddenly the TV at the other end of the room switches itself on and my attention transfers itself to what is being said by the figures on the screen. I attend to what they are saying with the result that I no longer take in what is being said on the radio.

It is not a question of the radio becoming inaudible. I can still hear, for example, the alternation between male and female voices. But in paying attention to what the TV presenters are saying, I lose the intelligibility of the radio broadcast. In other words, my attention seems to be distributed between two sources of *meaning* rather than between two sources of sound.

Overheard

"I think television is the curse of the age. I used to think it was the aeroplane."

"I travelled on an American boat – though, speaking personally, I've never had any faith in American seamanship."

"I've never been much good at looking down steep ravines. How about you?"

"I can remember the time when you couldn't give snooker tables away."

Overseen

Through an aircraft window on coming in to land, a banner over the passengers' entrance:
"SPOKANE WELCOMES METHODIST MINISTERS".
As a general principle?

Notice in the lobby of the Hyatt Regency Hotel:
"WINNING IN DENTISTRY"

Reading

Chardin has a portrait of a philosopher reading. But we wouldn't want to say that he was seeing a page of print, although "seeing" print is a necessary condition of reading it. So it doesn't sound right to say that Chardin's philosopher is looking at his book, but simply that he is reading it. A typographer might be looking at the book, but in the act of appreciating the type, he would somehow have to exempt himself from the experience of reading the text.

The spared glance

While being photographed I am asked to turn my head away but to keep my eyes looking towards the camera. This sidelong glance is very popular with modern photographers, but you can see the same thing in many paintings. It undoubtedly has a peculiar vitality – it seems to imply that the glance has just alighted and that the subject has merely spared the look whilst otherwise engaged.

Another spared glance

In the *Portinari Altarpiece* in the Uffizi, the glance which St Margaret seems to "spare" in order to look at the ointment jar held by the Magdalene standing beside her. From the position of her head on her neck you can recognise that she will return a moment later to her pious reading. But if you isolate her as a pictorial detail, so that you can't see what her spared glance is directed at, you could easily confuse her appearance with that of the Virgin in Flemish Annunciations. Like St Margaret, the Virgin disengages her eyes from her book, but in this case she refrains from reading the better to hear what the angel is saying.

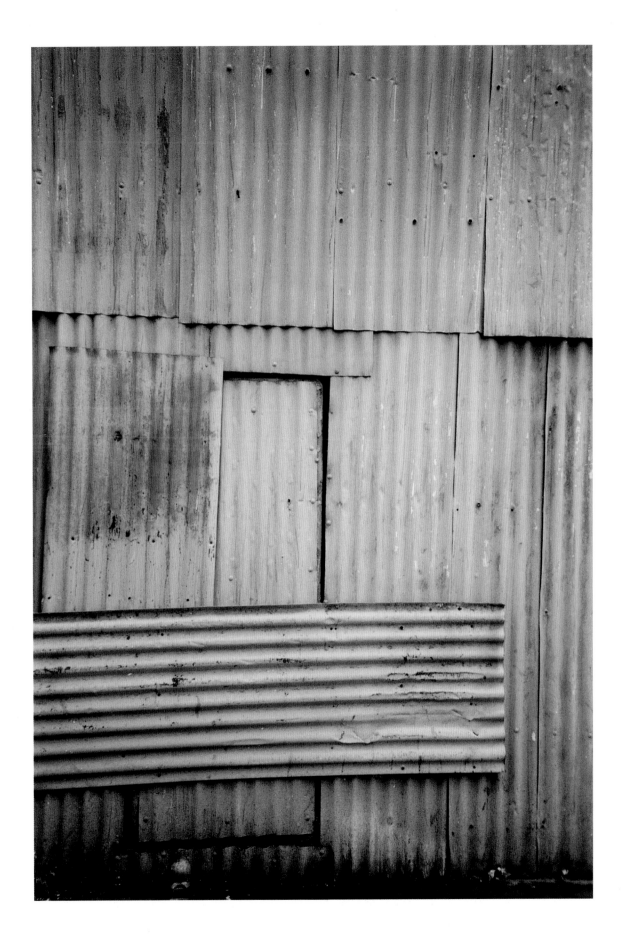

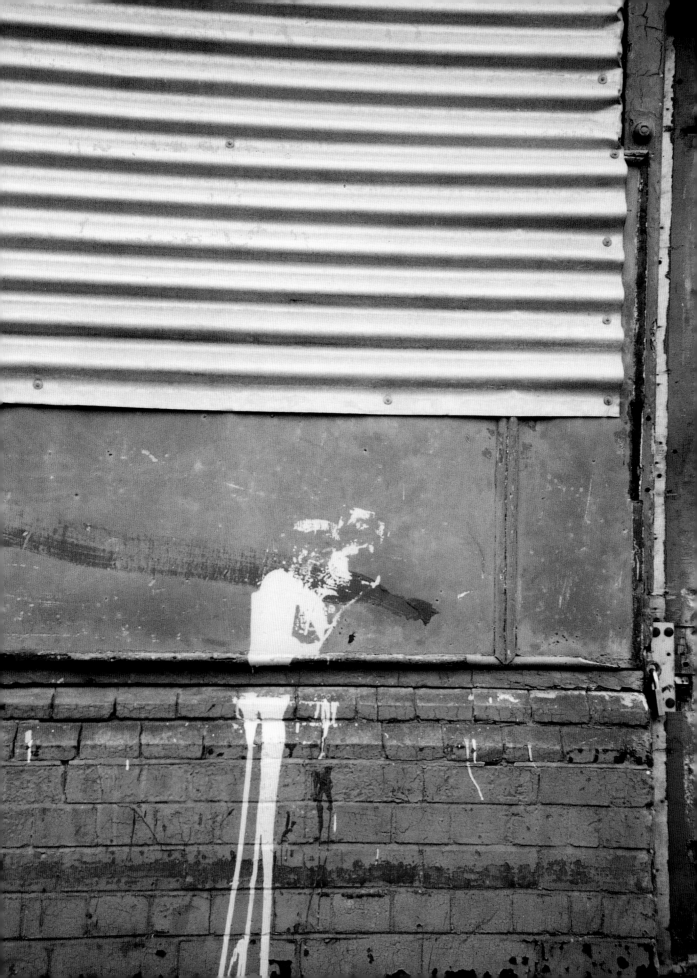

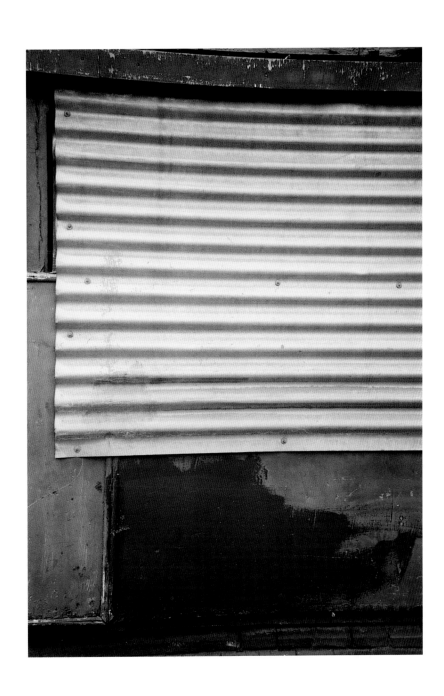

Representation

When we say that something is a representation, the assumption is that it somehow falls short of whatever it represents, although the way in which it falls short of it depends on the function the representation is expected to serve. At one end of the scale we have things we regard as substitutes or replacements rather than representations; *ie*, some substance, object or person which replaces a missing ingredient, part or role. In some cases the substitute is indistinguishable from whatever it replaces. The repair, as we say, is as good as new. When I say that the substitute is indistinguishable, this may just mean that it's *functionally* indistinguishable, though distinguishable in many of its other properties. An artificial kidney has none of the visible properties of the organ it replaces. It's a large machine that stands on the floor outside the body of the patient. But it *functions* at least in some respects like the missing kidney. We wouldn't want to say that it was a representation of the missing organ, though. On the contrary, we would be more likely to regard a functionally useless plastic model which *looked* like a kidney as a representation of one.

How about a working model of a kidney which reproduced some, though not perhaps all, of its physiological functions? It is not serving a patient nor does it look like a kidney, but since it illustrates the *function* of that organ we would have no hesitation in calling it a representation. What one would *want* to say, then, is that it represents the function of a kidney as opposed to its appearance.

Ways in which a person can be represented

By a deputy – that is to say, by someone appointed to act, as we say, on behalf of the person in question. As, for example, when the vice-president represents the president at a state funeral. He doesn't represent the president by virtue of his resemblance. He doesn't represent him any better by being his twin or by wearing his clothes, nor is his function compromised if he happens to have only one leg. He represents not the man but the office, by being formally declared as such. In other words, although he represents the president he is not a *representation* of him but rather he is his *representative*. And what makes him a *representative* is some legislative act to that effect. In other words, his competence is created by fiat and it has little or nothing to do with his personal character. But there are other types of deputy in which the competence is a matter of skill rather than appointment – an understudy, for example. An actor who replaces a sick star does not fulfil the role by being declared a deputy; in fact, he is not really a deputy at all. He doesn't *represent* the missing actor in any sense. He represents rather the person he is now fortunate enough to play.

Both presidents and vice-presidents represent their country in that some, though not all of their actions, are taken on behalf of the country as a whole. But the president doesn't eat, drink and sleep on behalf of his country, and not all of his publicly visible actions represent his country either. When the president sends condolences or congratulations to another head of state, he does so, as we say, *officially,* and the action is recognised as being done on behalf of the country he represents.

An understudy doesn't act on behalf of a missing actor, he replaces him in the role. Nor does the understudy *pretend* to be the actor who is off for the night. But there is a sense in which both the star and his understudy are pretending to be the person in the play. *Vis-à-vis* pretence in this context, there is an obvious difference between pretending to be Othello and pretending to be a doctor in order to get ladies to take off their clothes.

In pretending to be Othello, the actor is not trying to convince the audience that he is someone actual called Othello, but that he is someone called Othello who fictionally exists in a make-believe world. And even when an actor plays an actual living character, he's not pretending to be that person in the sense that he would expect, if his pretence was successful, to be personally praised or blamed for the pretended versions of the actual

behaviour that he played. On the other hand, what about an actor who was secretly invited to pretend to be a living head of state in order to reassure the public that the sick or possibly dead statesman was alive and kicking. If his impersonation were successful, who would get the praise or blame for his pretended actions? In the case of an actor standing in for his sick colleague, he would, if successful in the role, accept the praise on his own behalf for a performance as good as (if not better than) the person he was standing in for. He wouldn't have to accept the applause on behalf of the invalid since his performance is a functional replacement and not a ceremonial substitute.

Madness

Polonius says that Hamlet is mad but admits that there is some difficulty in defining what madness is. Would he have had the same difficulty, if he had been alive at the time, in objecting to Gertrude's claim that Hamlet was fat?

Upside down

I write down someone's initials M W and only later become aware of the fact that the second letter is simply the first one upside down. Now, although I wrote them both effortlessly, thinking of one as M and the other as W, I would have found it difficult to write down the second one while thinking of it as an M upside down. In other words, although the character W is the character M rotated through 180 degrees, it was only by thinking of it as a W the right way up that I could write it without thinking.

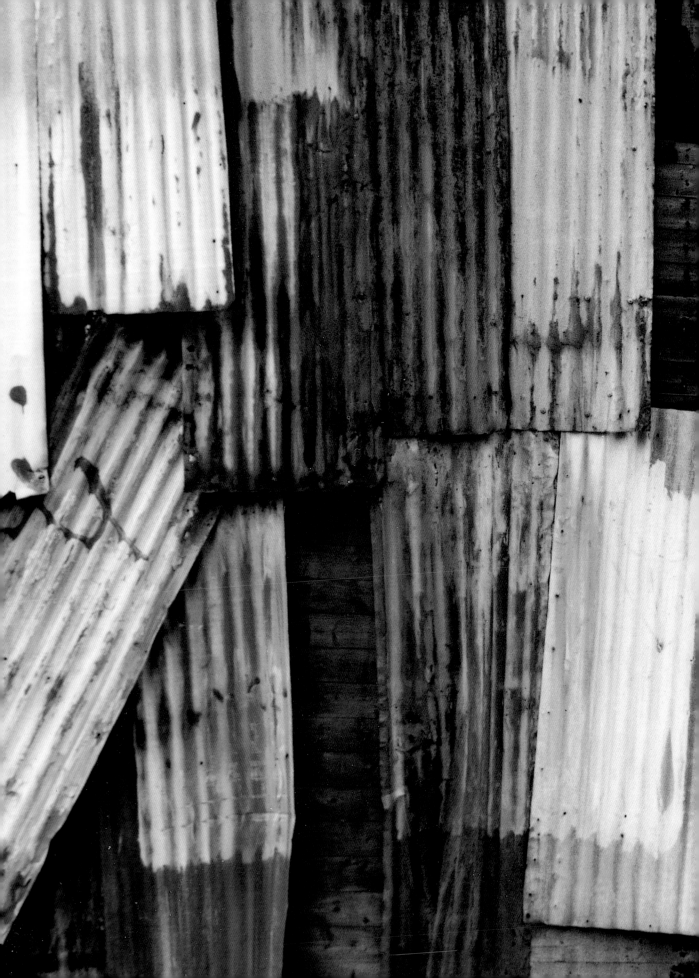

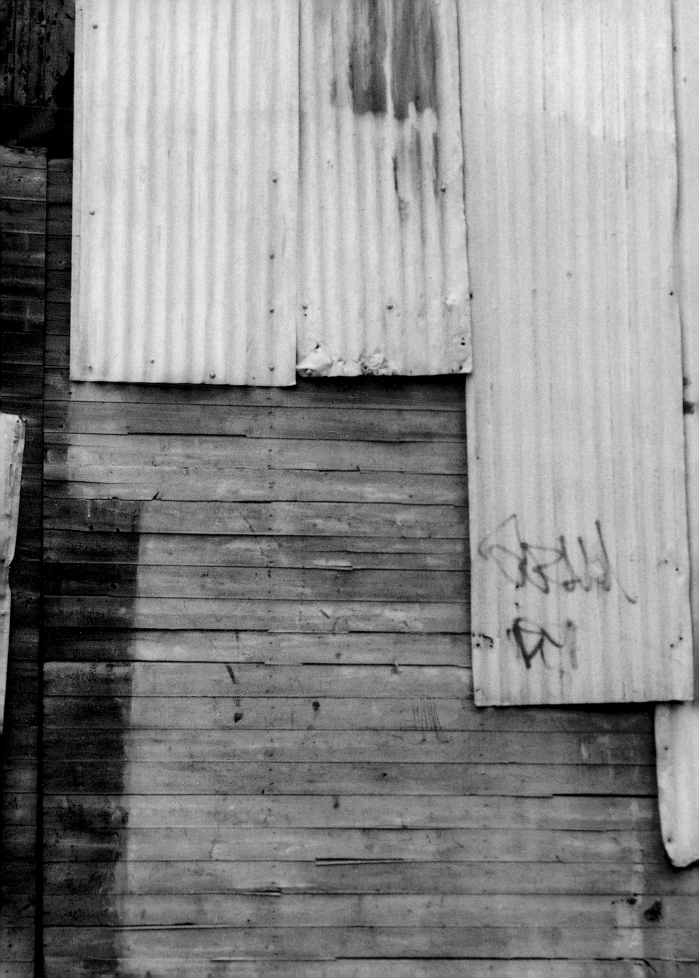

'Push-pin' and poetry

The story goes that John Stuart Mill recovered from his clinical depression by reading Wordsworth. I suspect that it worked the other way around. For someone brought up by a father to think that poetry was little better than 'push-pin', getting ill was probably the very thing he needed to take Wordsworth seriously; and that his willingness to pick up the *Prelude* and actually read it was the first sign of his getting better.

House guest

"I travel very heavily," said J as he arrived for a short visit. He set down a Hacker radio set and a green plastic Harrods bag filled, so it turned out, with sketching things – good broken pastels and notebooks to record the details of his visit.

 He disappears several times a day to keep the journals up to date. We get the uneasy sense of being recorded. He seems to see himself as a private secretary to posterity. He departs, forgetting many objects, one by one declared by telephone to be of great sentimental value – mementos of previous visits. A professional guest, paying his way with a vague promise of posthumous mentions.

Nietzsche on Wagner

All of Wagner's heroines, without exception, as soon as they are stripped of their heroic skin, become almost indistinguishable from Madame Bovary.

Photographic smiles

William came back from school today complaining that the photographer refused to snap him until he smiled and it seems that the poor fellow had to pull faces before he could get what he wanted from William. But why did he want a smile in the first place? Why are photographers so eager to get smiles and go to the length of getting people to say "cheese" in order to obtain them? It seems to have something to do with photography rather than portraiture as such. After all, there aren't many smiling faces in painting – so few, in fact, that they are generally noted for their smiles. The *Laughing Cavalier*, the *Mona Lisa* and so on. To some extent, of course, this is because no one could hold a smile through the length of a pose – it would soon become a *rictus*. And when painters *did* catch a smile, that is to say without the sitter having to hold it for hours, it was a proof of the artists' skill rather than an illustration of the subjects' personality. And the same goes for Victorian photographs: the film was too slow to catch anything but a rictus. No one smiles in Julia Margaret Cameron's plates. But did anyone feel that they were missing smiles at the time? Did everyone breathe a sigh of relief when film eventually became fast enough to capture a grin? And yet for some reason the introduction of fast film coincided with the request – no, the demand – that the subject prepare his or her face for photography by giving a smile.

 Why is a smile so important that the photographer will even put up with an artificial version of one? I wonder if it has something to do with friendliness, and that modern snapshots are not simply records of the subject portrayed, but rather a representation of the relationship between the subject and the invisible photographer ... the hope being that when the photo is discovered years later, perhaps the smile conjures up the image of an encounter between two people, one of whom departed without leaving a visible record of himself.

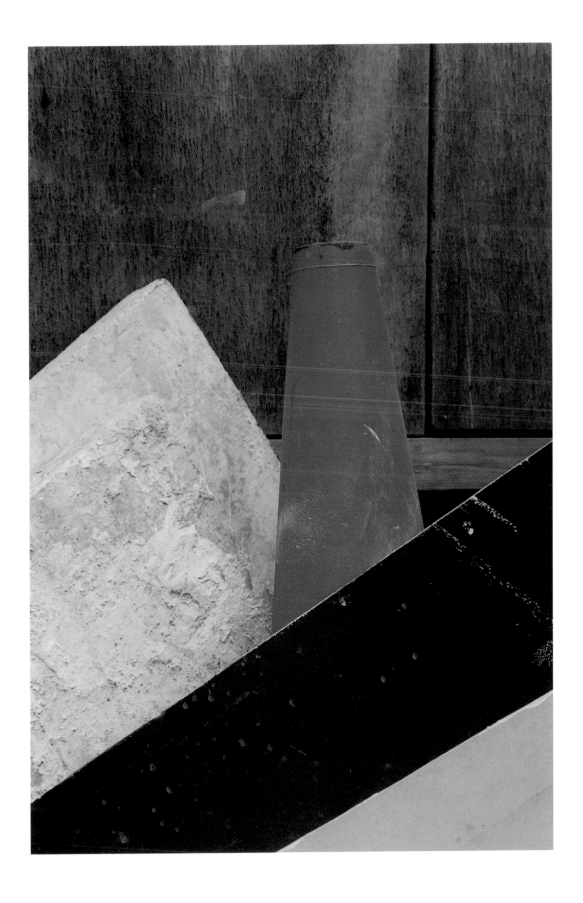

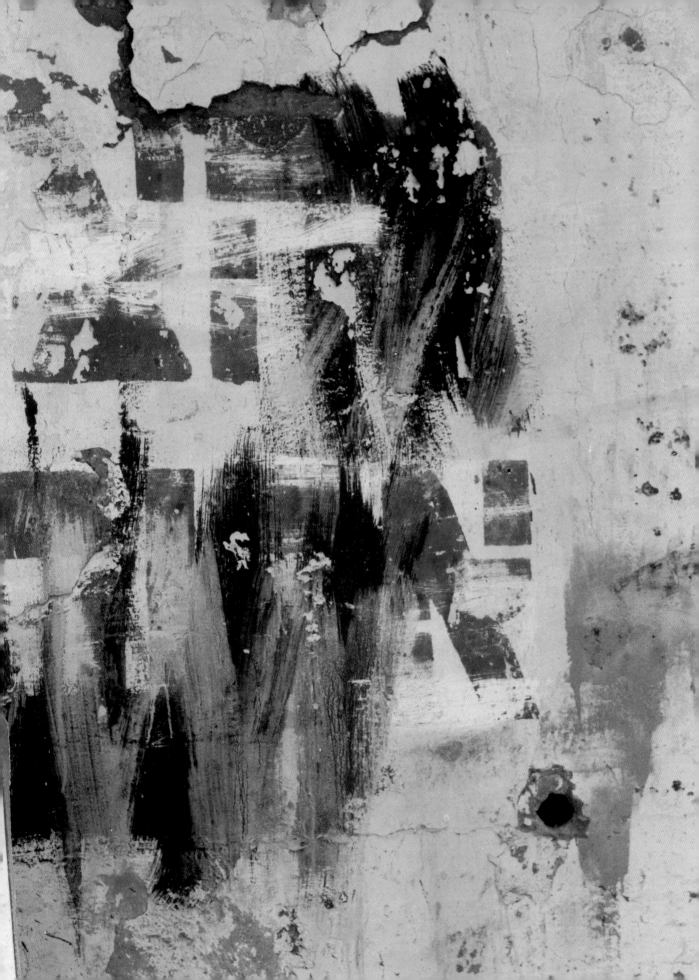

Overheard in a train to Lewes

"They have got beautiful sands in Douglas. They just don't know the meaning of dangerous beaches."

"On our way down to Alfriston the other day we got held up by a Panda policeman who said there was cows in the lane. I reckon the lead cow was the black sheep of the family."

A view

From a high embankment the train passes a row of suburban back gardens. One leg of a huge electricity pylon rises out of someone's vegetable garden and carries the drooping cables off and away to another distant tower. The owner has leaned a bunch of gardening tools against the foot of the pylon. Small domestic implements leaning against the arrested stride of something vast going elsewhere, beyond the knowledge and even the possible imaginings of the gardener himself. Perhaps he doesn't even know what he's propped his tools against and it's only from the privileged view of the embankment that we can see the dreadful truth.

Partings at the airport

The prolonged farewell embraces of fat, unattractive families. Prolonged holdings, with heads over each others shoulders, swaying tearfully backwards and forwards, one hand patting the other's shoulder in a gesture of impotent consolation. Shamefaced pulling apart, avoiding each other's tearful eyes. One turns away, sulkily and almost angrily rubbing the inflamed cheek, as if the parting were just the latest in a series of unfair blows dealt out by life – along with fatness and poverty.

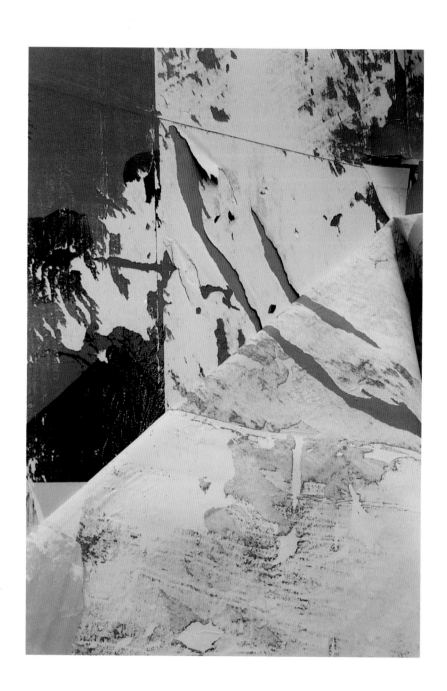

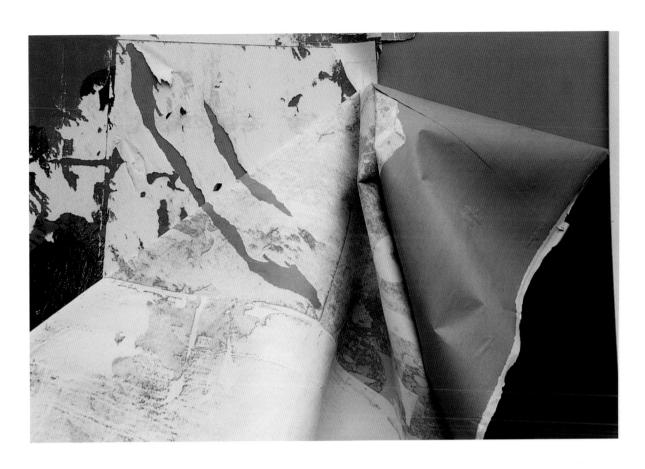

Solving dramatic problems, April 7, 1976

The beard in the fourth act of *Three Sisters*. It could just be a moment of bathos to counterbalance Masha's grief at the departure of Vershinin.

In fact, we weren't actually thinking about it at all – the issue of what was meant or what might have been meant by it only came up as a result of trying to work out the subsidiary problem of exactly when Kuligin – Masha's husband – was to take the false beard off. By rights, or at least by common sense, he should take off what was only meant as a joke at the moment when Natasha comes in and seems to be frightened by it. For some reason, though, I told AB (playing Kuligin) to keep it on – to brazen it out, both as an actor and as the character – and suddenly we discovered a better and more touching use for what had previously been a comic device on Chekhov's part. Immediately after Natasha's exit I asked JS (playing Masha) to go across to Kuligin, say, "It's time to go," and then to tenderly take off the beard for him. In other words, to unmask him and to discover under the woolly absurdity of this comic prop, the serious, concerned face of her hitherto neglected and despised husband – as if by having concealed himself under a deliberately assumed absurdity he could for the first time reappear free (in her eyes at least) of his natural and inadvertent foolishness. It was as if, under the beard which he had put on after all only as a joke, he had changed for her, Masha, and his natural dignity had unexpectedly become apparent.

God knows how it worked, but he went *into* that beard as an insensitive clown and emerged from it as a man of dignity and patient forgiveness. But we had to find all that out, and we only did so by solving the apparently trivial problem of when to take off a false beard.

Another problem

How to get Masha onto the stage for her long-awaited and dreaded farewell to the departing Vershinin. J quite rightly said that she would do anything to avoid racing onto the stage distractedly. How should she come in, then? Naturally she *is* distracted or she will *become* distracted by the farewell scene which is to follow. Perhaps this is what she, Masha, dreads. In other words, she dreads not only the departure, but her own behaviour during the farewell which marks it.

For some reason JS and I visualised this moment in the same way. Instead of rushing onto the stage like a demented banshee, she might arrive self-effacingly, sullenly reluctant to draw attention to her presence, wanting to be found rather than declaring her arrival, as if to imply, "I know you care less about our parting than I do – so I won't throw myself at you with my insufferable misery – though you must be able to tell from the way I am standing here unobtrusively that I am grieving. So there!"

Or it could be that she recognises that she doesn't know her part for such a scene and hangs back in sullen fearfulness from a situation for which there is no adequate ceremony. All this is made so much worse by the fact that whatever she does will be witnessed by other people. In the end, of course, her uncontrollable tears solve the problem for her – the very thing that Vershinin would have been dreading.

So while Masha's problem is solved by the relief of breaking down, Vershinin's situation is made just as difficult as he feared it would be by her doing so. The paradox is that in working out how this scene and this moment should go, we suddenly understood a great deal more about the relationship between Vershinin and Masha earlier on in the play. Someone who has never worked on a play would probably assume that you would work out the relationship between Vershinin and Masha in chronological order and what you established in *earlier* scenes would automatically determine the behaviour in the last scene.

Among other things, *Three Sisters* is about time and how we experience and endure it. "You must be Olga the eldest – you're Marya and you must be Irina, the youngest." There are references to the passage of time on almost every page starting with the first speech. "It's exactly a year since father died. This very day – your Saint's Day." And the date of Irina's Saint's Day is used to mark the passage of time since then. "It was your Saint's Day," says Baron Tuzenbach, as he tries to remember the moment when he first fell in love with Irina. And then when Andrei asks Natasha when it was that he first began to love her. Then, as Olga recalls when they all left Moscow, "And it seems like yesterday." To some characters the past is vividly present – as if it were yesterday – and to others it seems lost altogether. "I must admit I don't remember you at all," says Vershinin in the first scene. All he can remember is

that there were three sisters, but he clearly remembers their father: "I only have to close my eyes and I can see him standing there as if he were still alive."

Vershinin himself is both forgotten and remembered by the three girls: "I am afraid I don't remember you at all," says Masha and then a few speeches later she says, "Olga, you remember. There *was* someone we used to call the lovesick Major. Oh, how you have changed!" In the act of remembering him, Masha realises that he must have changed – as if there were no other explanation for her not having recognised him at the outset.

Which raises the second issue of time in the play: that things, and especially people, are altered by time. "I was in love, then," explains Vershinin. "Things are different now." Or Olga's words at the beginning of the first scene: "A year ago since father died. I thought I'd never get over it and now we can talk about it quite easily. You're wearing white and your face looks absolutely radiant." So grief will be forgotten and even those we grieved for: "You know, I can hardly remember what mother looked like. Oh, well, we'll all be forgotten." And then of course they try to anticipate the time when all of them *will* be forgotten: "Let's try to imagine what life will be like after we are dead. In two or three hundred years time, say."

Of course, although we shall be forgotten and no one will remember who we were or what we were like, we *will*, as Vershinin points out, have a stake in the future we'll never visit, if only because we will have contributed something to whatever follows. Process and Reality, to use Whitehead's phrase, are continuous. Although we can artificially cut up time into discrete episodes or instants, either by memory or by photography – don't forget that moment when they all pose for a group photograph in the first scene – things actually lead on to one another without any break or interruption. We may not experience the posterity we imagine, but it won't come into existence without our actions. The happiness which Vershinin confidently anticipates is built out of the previous suffering – although, of course, it supersedes it. In other words, it's no good supposing that one could enjoy future happiness by hibernating until it comes into existence of its own accord.

As in Proust, Chekhov uses the metaphor of photography. A photo of Irina is taken at the end of the first act and at the start of the last – on her Name Day and then on what she incorrectly supposes will be her wedding

day. Two recorded instants separated by a long stretch of unrecorded time (and each photo, of course, taking time to take) And then how about that humming top in the first act – a brief summary of the passage of life through time. Once it is set going, it hums hypnotically in the attentive silence, gradually falls silent, wobbles and falls over.

Hamlet and his uncle

Many tribal societies allow a peculiar affectionate disrespect between a man and his mother's brother. It's as if the mother's brother were an extension of her – a benevolent male mother. Perhaps this explains the peculiar hostility felt by Hamlet for his *father's* brother. Hamlet visualises and reacts to his paternal uncle as an extension of the father, allowing the hostility which he might otherwise illegitimately feel for his father to be displaced onto his fraternal *Doppelgänger*.

Acting

A performer's movements can be described in terms of the elusive concept of "phrasing". Something too subtle to be easily described, without which the performer's actions seem perfunctory and unfinished. In fact, there's an interesting overlap between the notion of "finish" and that of "finesse". One of the most important features of a gestural "phrase" is the mode and rate of its conclusion – the sense of an ending.

Outlines, July 1975

Silhouetted against the featureless radiance of the sunlit pavement I catch sight of an Arab woman in a black robe. All at once a light wind blows the black drapery from the left side of her body and spreads her shape into an uneven trapezoid. Since it's impossible to distinguish her body from her robe, it's as if she has spread like a dark amoeba. Perhaps we are all like that – barely discernible persons within the ceaselessly changing outline of our psychological draperies.

Flemish narrative

In *Marriage of the Virgin* by the Master of the Tiburtine Sybil, the events of the Virgin's life leading up to the marriage, including the miraculous details of her birth, are to be seen on the far side of a balustrade, out in the open air, beyond the framed porch in which the marriage itself is taking place. We are to understand (though how?) that beyond the balustrade does not mean "outside the house and at the same time" but something previous to the main scene.

Roles

Someone can be a body, a cloud of atoms, a bunch of cells, an organism, a person, a father, a Frenchman, a villain or a candidate. Only certain things can happen to each of these entities. You can't execute a cloud of atoms and you can't run an election campaign on behalf of a bunch of cells.

The storied capitals in Autun

The right-angled corner of the capital can be incorporated into the pictorial design in one of two ways. As a geographical feature around which the story winds continuously as the characters in the narrative turn such a corner, or as a *symbolic* break which represents a conceptual contrast between the figures shown on one side and those to be seen on the other. There is a nice example of the second version in the Romanesque capital which is carved to show the adoration of the Magi. On the longer anterior surface, the Three Kings kneel in front of the Virgin, who holds the infant Jesus on her lap. Seen from the front, Joseph is conspicuously absent from the scene. But on the narrow side face of the capital – that is to say round the corner – Joseph is to be seen with his head resting on his hand. Now this arrangement could be read as a complete scene in which Joseph just happens to be seated round the corner but is nevertheless "in the picture", but I suspect that Joseph is symbolically *excluded* from the picture just as he is excluded from the paternity of the Holy Child.

The windows in Chartres

Seen with the naked eye, as they were presumably expected to be seen, the windows are decorative rather than pictorial, jewelled ornaments pricked out of the darkness with little or no impression of illustration. The scenic aspect of these shining lozenges only becomes apparent when viewed through binoculars. How odd to go to that much trouble when no one could have seen what the modern tourist can.

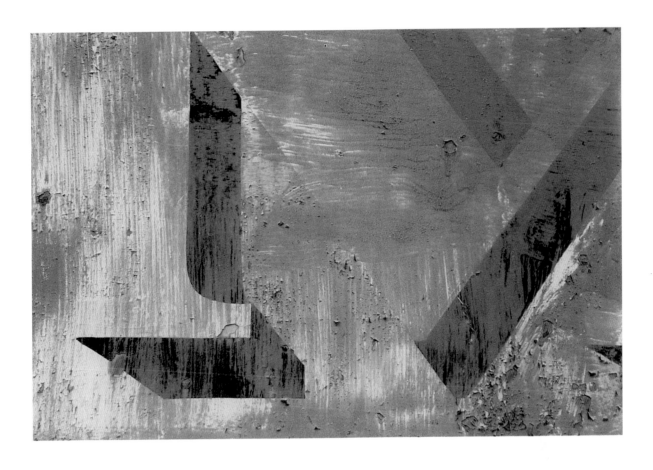

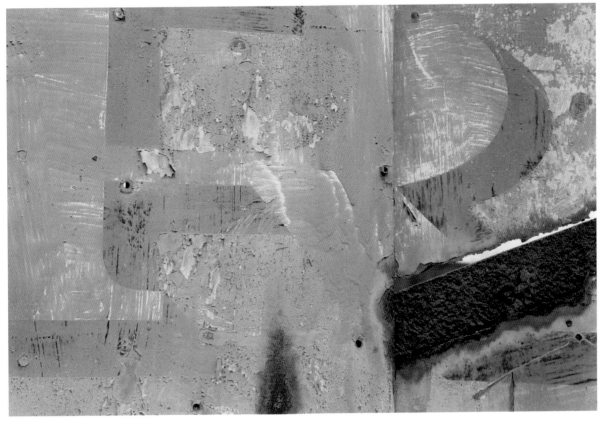

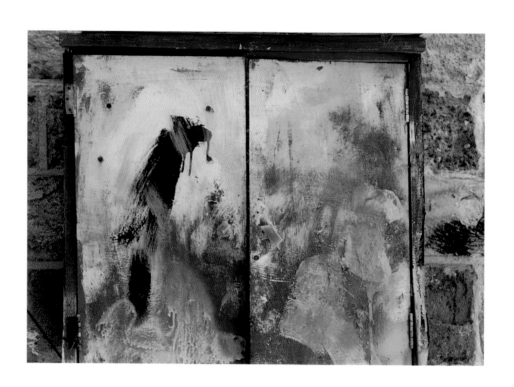

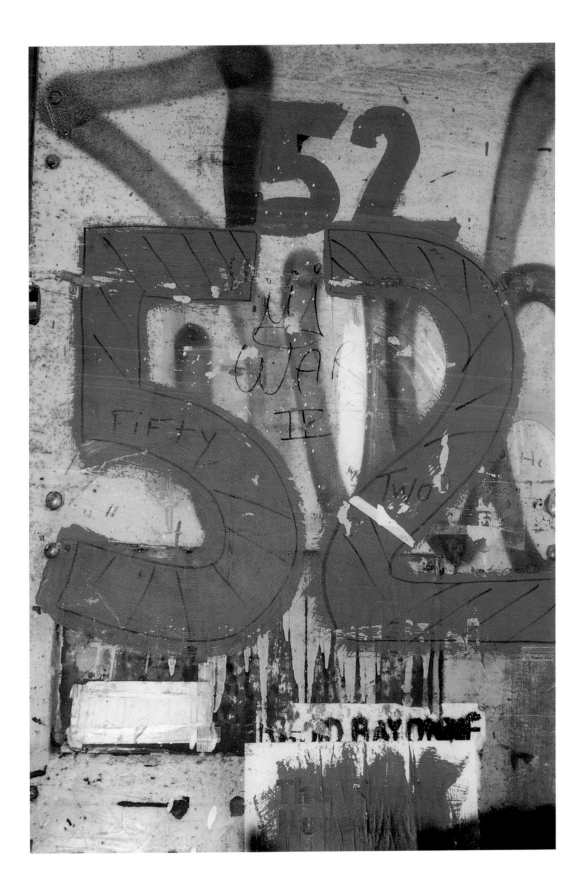

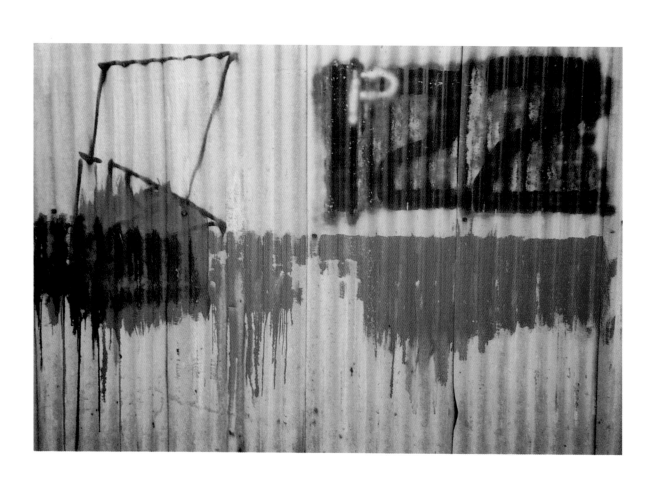

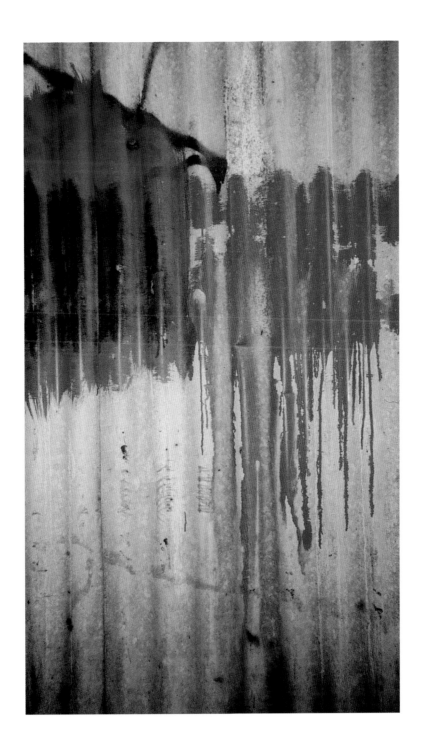

Dream images

In his *Philosophy of Sleep*, the 19th-century Scottish writer McNish describes a dream in which he saw Versailles as a Gothic pile. Compare this with someone wide awake who sees a Gothic pile and in ignorance of its real identity takes it for Versailles. The difference between the two cases is shown by the way in which the idea of correction applies to each one respectively. The dreamer, on waking, does not recognise that he has made a mistake and say to himself, "I can see now, but didn't then, that what I saw in my dream was something other than Versailles"; rather he says, "How odd that Versailles should have had such an appearance in my dream." Whereas, someone who learns to his embarrassment that the Gothic pile he took for Versailles was nothing of the sort learns not to make that mistake again. The point is, I think, that when someone dreams of Versailles as Gothic, as opposed to seeing something Gothic and mistakenly thinking it to be Versailles, the experience is intrinsically paradoxical. It's as if one knew all along that the familiar façade was in disguise and that it was somehow pulling a fast one.

Dreaming

It's possible to wake quite slowly from a nasty dream and it may take some time to recognise the fact that one has been unhappily awake for several minutes. You can roll gently in and out of restless sleep, imperceptibly passing from the imagery of dream to the train of wakeful thought, like a half-drowned sailor washed backwards and forwards in the shallow breakers at the low-tide line – gradually and unnoticeably left high and dry by the retreating waters of sleep so that one can only tell from one's exhausted misery that one was recently afloat in sleep and dreaming unhappily.

King Lear

"Who is it who can tell me who I am?" The recurrent theme of flatteries , insults and home truths.

The risk of being a king, especially one who has "ever slenderly known himself", is that he is susceptible to untruthful flatteries. A corrective is offered by the fool who repeatedly insults the king. "Do'st call me fool?" "All thy other titles thou hast given away. That thou wast born with."

That word *titles* – names and offices conferred by ceremony as opposed to what we are born with "when we first come to this great stage of fools".

Then there are the *insults* given by Kent to Oswald – and of course Oswald's insulting behaviour to Lear. "Who am I, *sir*?" "My lady's father."

An insult by default. Lear is, of course, *My lady's father* but he is or was a king. Though not, as Lear later claims, "every inch a king".

Offence versus insult

The two are not necessarily identical. For certain offences to be taken as an insult it may be necessary for the offended person to take account of a third party who has witnessed the incident. Last night I was standing at a bus-stop in Camden Town. Just ahead of me stood a respectable old lady. Within earshot of both of us there were two vigorously swearing labourers. The old lady could scarcely avoid hearing what to her must have been offensive words. But she showed no sign of it until she accidentally caught my eye. She now knew that she had been overseen overhearing and that she was therefore obliged to take up the option of feeling insulted, and blushed.

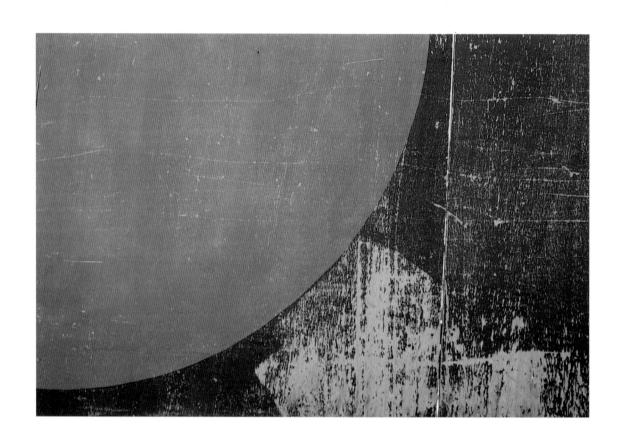

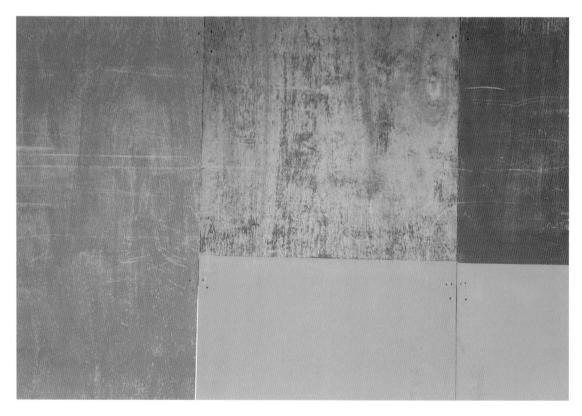

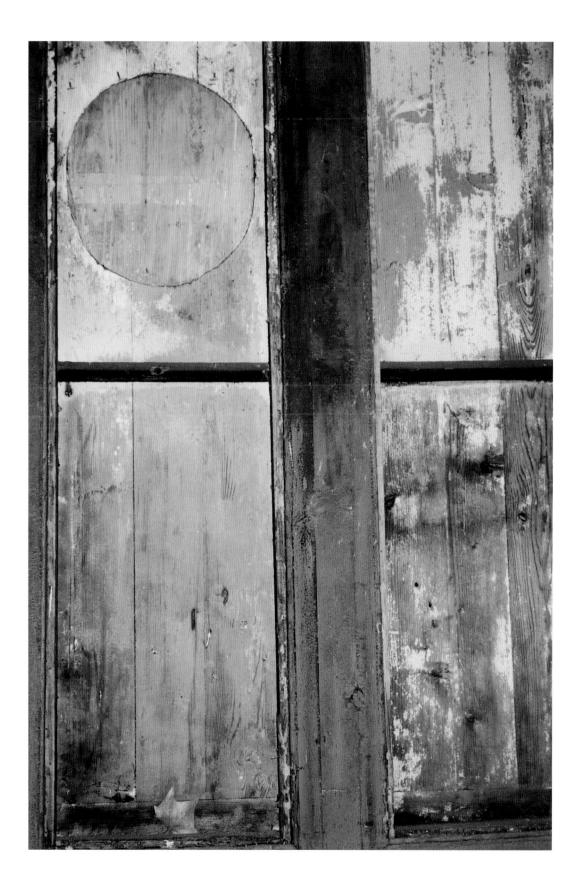

Time present and time past

In realistic painting, the juxtaposition of people or objects within the same pictorial frame implies that they are co-existent: a group portrait of the members of the Linen Drapers Guild, for example, or a still life by Chardin. So how about the Giovanni di Paolo in the Kress Collection? Within the loggia, whose alcoves recede realistically into the distance, we can see the Annunciation. But in the park just outside, Adam and Eve are being driven from Eden, an event which cannot be co-existent with the Annunciation. And yet the painter leaves us in no doubt as to the *spatial* co-existence of the loggia and the park outside. The park can be seen behind and through the colonnade on the left-hand side of the loggia. On the right-hand side of the loggia, however, just behind the seated Virgin, there is a blank wall, partly cut away so that we can see Joseph warming himself at the fire in what is presumably another room. So that on the left-hand side of the picture, in the parkland just outside the loggia, we see events which are historically antecedent to the Annunciation. But on the opposite side, just as realistically, Joseph is obviously sitting in another room at the same moment as the Annunciation.

Being looked at

The appearance of someone who happens to be the subject of public scrutiny. Someone who is – as Hamlet is, for example – the observed of all observers and therefore disengages his regard from any one of his many onlookers, thus preserving his regally receptive aloofness.
There is a nice example of this to be seen in the glance of the young Medici who ascends the steps in one of Ghirlandaio's frescoes in the Sasetti Chapel of the S Trinita in Florence. As he rises into public view, his gaze ranges impersonally over the invisible spectators, who take in the arrival of this privileged youngster.

Types of gaze

a Perceptual. Looking in order to see. Directing the eye-line in order to examine, inspect, observe. All of these are examples of looking at what is there. But then there is searching – *ie*, looking with a view to finding or recognising something not yet seen.

b Indicative. Ostentatiously directing one's gaze with the purpose of getting someone else to direct his or her gaze to the same thing. This is often accompanied, of course, by pointing. But when there's a question of confidential secrecy and there is one person and one person only whose attention you wish to attract to the area in question, when pointing would draw the unwanted attention of others, A looks secretly at B and swivels his eyes towards the object or person of interest, in the hope that B and B alone will be privy to the indication.

c Expressive – gazes by means of which someone silently tries to influence the mood or the actions of someone else. In Tintoretto's *Venus and Adonis*, the Goddess fixes her eyes upon those of Adonis thereby imploring him not to leave for the hunt. The silent exchange of glances between two people who thus tacitly express a shared opinion about the behaviour or statements of a third party. Mutually adoring looks.

The legibility of such expressive looks obviously depends on something more than mere eye contact. The context is obviously important. But the meaning of a "look" is also determined by the facial expression that accompanies it. A love-lorn look at someone won't necessarily be read as such unless the face as a whole wears the appropriate expression. All the same, mutual glances may be a necessary component of acts such as inquiring, threatening, regretting or apologising. In other words, they are the non-verbal equivalent of what John Searle calls "speech acts".

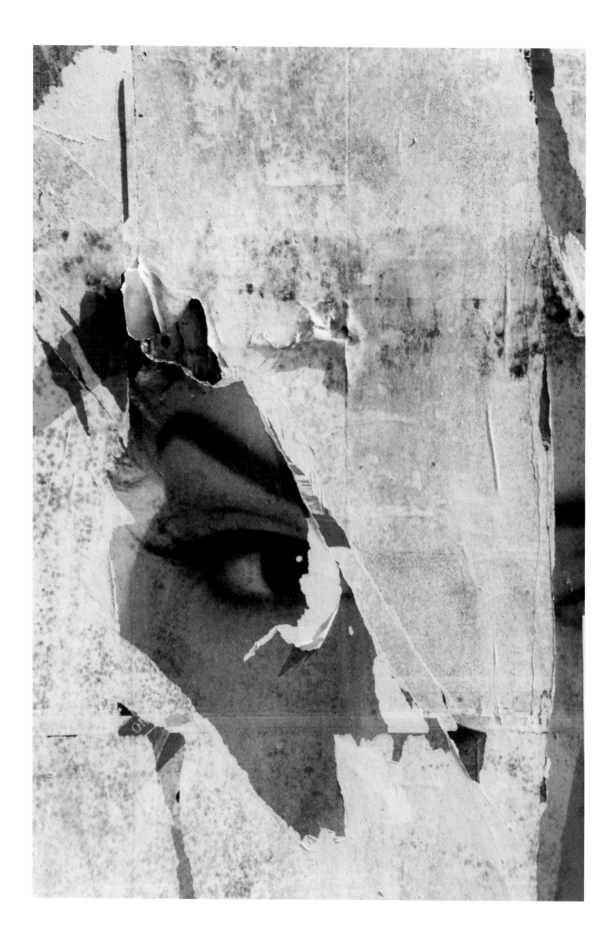

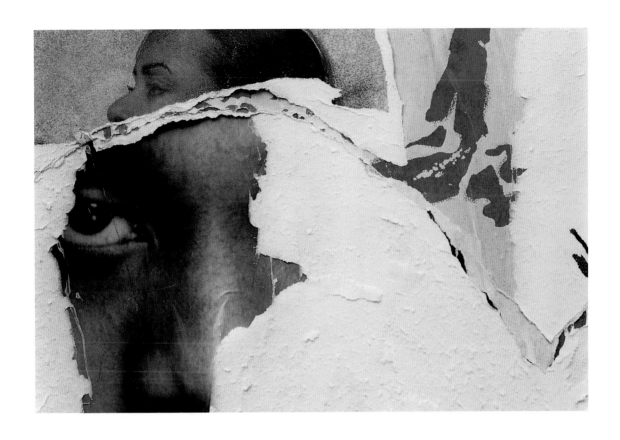

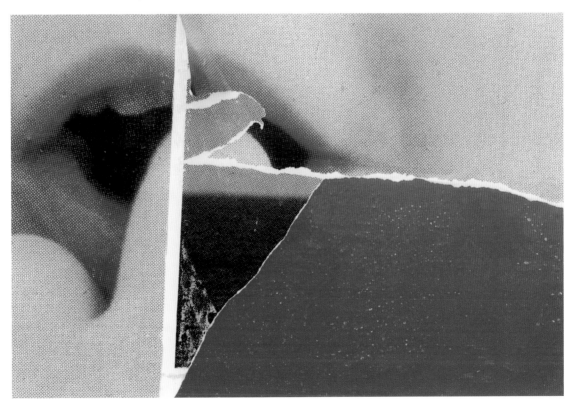

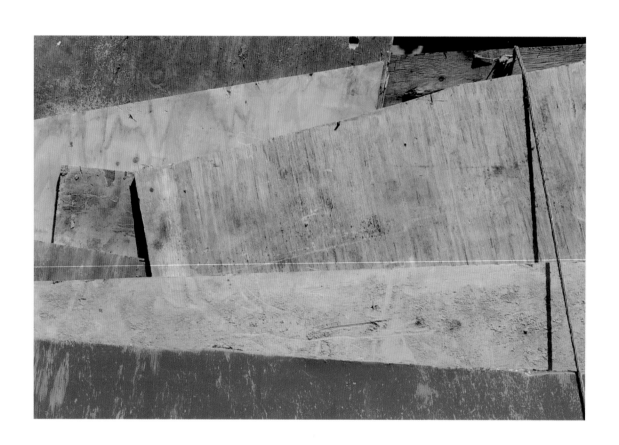

Further thought about looking

Looking at what one is doing. This is a distinctive form of looking at something, in that one can be completely blind to almost every visible aspect of whatever it is that intercepts one's eye-line, because the eyes are here employed in guiding action and nothing else. For example, in Manet's *Execution of the Emperor Maximillian*, it sounds rather odd to say that the soldiers are looking at the victim, and this is not entirely to do with the fact that their gaze is fastened on such a small and uninteresting part of the unfortunate man.

What they are doing is *aiming* so that what they are looking *at* is something that one wouldn't normally attend to at all – *ie*, the distance between the muzzle of the gun and the supposed position of the Emperor Maximillian's heart. And the same goes for any picture in which people are shown looking at what they are doing. They're keeping tracks of their own actions.

Visions

The traditional motif of St Luke painting the Virgin might not be exactly what the title implies. In Rogier van der Weyden's version, St Luke is unarguably painting the Virgin, but if you look carefully at his eye-line, it's not actually directed *at* her. In fact, his gaze doesn't seem to be directed at anything in particular. Perhaps, then – and more interestingly – he is painting not what he *sees* but what he *imagines* or *visualises*, which means that Rogier has included *his* portrait of the Virgin to help us understand what *St Luke* is envisioning. So that the visual experience represented in Rogier's picture is subtly different from the one which is represented in Fillipino Lippi's painting in the Badia. In this picture there is no question of St Bernadino *imagining* the Virgin as St Luke seems to be doing in Rogier's painting. Nor is he seeing her in the conventional sense; rather he is having a *vision* of her.

Vacant gazes

There are many pictures and, of course, real-life situations in which the eyes, though open, are not seeing anything. Not because they are blind, but because their owner is, as we say, off in a world of their own.

One of the most familiar examples of this is the look of people talking on the telephone. As they chatter away, their gaze is raised obliquely, not necessarily because they are half-attending to something on the ceiling, but because they are wholly absorbed by what they are listening to and have therefore unhooked or disengaged their eyes from the world around them.

Averted gazes

Strictly speaking, the averted gazes we often see in paintings are ones in which the person actively *refrains* from looking at what is self-evidently the principal subject of the painting. For example the shocked diners at Herod's feast who deliberately turn their eyes away from the dreadful spectacle of the Baptist's severed head. Another example is the young girl who turns fearfully away from the asphyxiated bird in Wright of Derby's *Experiment on a Bird in the Air Pump*. Such averted gazes are to be distinguished from ones in which the represented figures pursue their own interests, apparently unaware of the dramatic event referred to in the title of the picture. In other words they are not turning away *from* anything – they are simply otherwise engaged.

But there is another sort of averted gaze to be seen in paintings. It's one in which the subject appears to disengage visual attention to this or that, the better to concentrate on something non-visual. For example, in Frans von Mieres' *Doctor's Visit to the Sick Girl*, the physician conspicuously turns his gaze away from the patient's wrist the better to concentrate on the pulse which he *feels* there. You can see something similar in Caravaggio's group of young musicians. The young man tuning his guitar looks skyward as if to concentrate on the sound of the plucked strings, the sight of which might distract him.

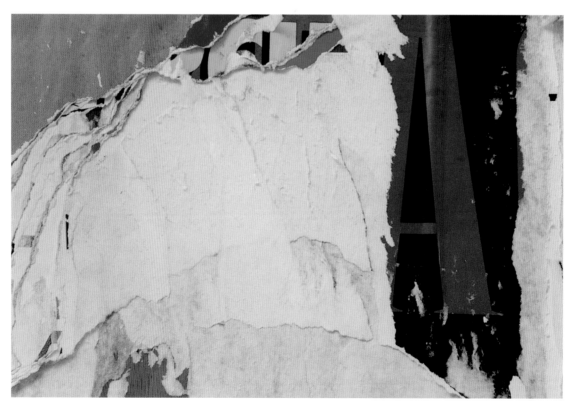

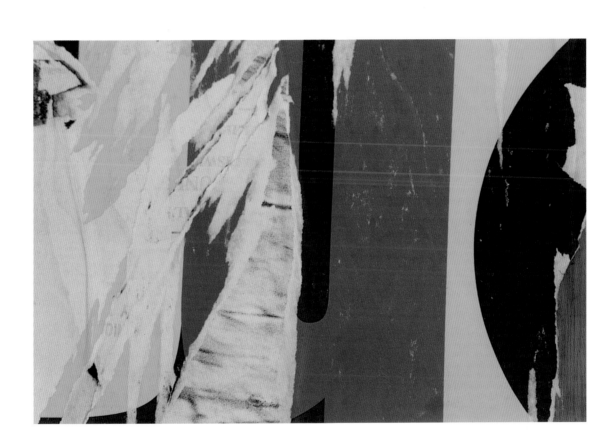

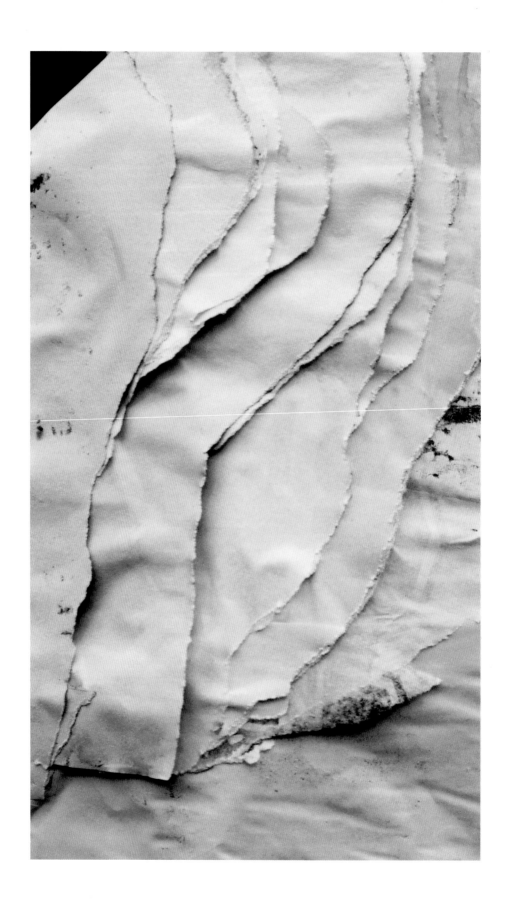

Endpapers by Rebecca Wilson aged 10½
Thank you to St. Michael's C.E. Aided Primary School
for helping with the endpapers - K.P.

To Katya Wright K.P.
To my lovely sister Moya and her beautiful husband Basil V.T.

OXFORD
UNIVERSITY PRESS

Great Clarendon Street, Oxford OX2 6DP

Oxford University Press is a department of the University of Oxford.
It furthers the University's objective of excellence in research, scholarship,
and education by publishing worldwide in

Oxford New York

Auckland Bangkok Buenos Aires Cape Town Chennai
Dar es Salaam Delhi Hong Kong Istanbul Karachi Kolkata
Kuala Lumpur Madrid Melbourne Mexico City Mumbai Nairobi
São Paulo Shanghai Taipei Tokyo Toronto

Oxford is a registered trade mark of Oxford University Press
in the UK and in certain other countries

Text © Valerie Thomas 2003
Illustrations © Korky Paul 2003
The moral rights of the author and artist have been asserted
Database right Oxford University Press (maker)

First published in 2003

British Library Cataloguing in Publication Data available

ISBN 0-19-279129-X Hardback

1 3 5 7 9 10 8 6 4 2

Printed in Belgium

Winnie's NEW COMPUTER

Korky Paul and Valerie Thomas

OXFORD

UNIVERSITY PRESS

Winnie the Witch had a new computer.
She was very excited.
Her cat, Wilbur, was excited too.
He thought something interesting might
happen and he didn't want to miss it.

Winnie plugged in the computer,
turned it on, and clicked the mouse.
'Come on, mouse,' she said.

Is that a *mouse*? thought Wilbur.
It doesn't look like one.

Winnie went on to the internet.
Wilbur wanted a closer look at the mouse.
He patted it.

'Don't touch the mouse, Wilbur!' said Winnie.
'I want to order a new wand!'

Wilbur patted the mouse again. Pat, pat.

Winnie was cross.
She put Wilbur outside.
She didn't notice that it was raining . . .

Wilbur noticed it was raining. He was getting wet.
He watched Winnie through the window.
She was having a good time.

She ordered her new wand, and then she
visited www.funnywitches.com.
They had some very funny jokes.
'Ha, ha, ha,' laughed Winnie.

Wilbur *wasn't* laughing.
The rain was dripping off his whiskers.
'Meeow,' he cried. 'Meeeooooww!'
But Winnie didn't hear him.

That mouse has put a spell on her, thought Wilbur.

plop plop plop plop plop plop plop **Plop**

Plop, plop, plop.
'What's that noise?' asked Winnie.

It was the rain.
It was coming through the roof.

'Oh no!' said Winnie. 'The rain
will ruin my new computer!
I need the Roof Repair Spell.'

But she couldn't find her book of spells
or her magic wand anywhere.

'Oh, where are they?' she cried
as the rain plopped down.

At last she found them.
She waved her wand seven
times at the roof, and shouted,

ABRACADABRA!

The roof stopped leaking.
'Thank goodness,' Winnie said.

Then she had a wonderful idea.

'If I scan all my spells into the computer,' she said,
'I won't need my book of spells any more.
I won't need to wave my magic wand.
I'll just use the computer. One click will do the trick.'

So Winnie loaded all her spells
into the new computer.
'I'd better try it out,' she said.
'What shall I do?'

'I know, I'll turn Wilbur into a blue cat.'

She let Wilbur inside. She went to the computer, clicked the mouse, and Wilbur was bright blue.

'Good!' said Winnie.
'It works!'

CLICK

CLICK

She clicked the mouse, and Wilbur was a black cat again.
An angry, wet, black cat.

'Well, Wilbur,' said Winnie, 'I won't need my book of spells or my magic wand any more.'

And she put them out for the dustman to take away.

That night, Wilbur waited until
he could hear Winnie snoring.
Then he crept downstairs.

He was going to see about that mouse.

He patted it.
Nothing happened.
'Meeow, grrrrrssss!' he snarled.
He grabbed the mouse, tossed it into
the air, and rolled onto his back.

Winnie had a lovely sleep.
In the morning she came downstairs
for her breakfast.

'Breakfast, Wilbur,' she called.
'Where are you, Wilbur?'

She looked in the garden, in the bathroom, in all the cupboards.
No Wilbur. Then she looked in the computer room . . .

'OH NO!!!' cried Winnie.
'Wilbur, where are you? And where's the computer?'

She reached into the cupboard for her book of spells. She put her hand in her pocket for her magic wand.

Then she remembered.

She ran to the window. The dustman was tipping her rubbish into his truck.

'Stop!' shouted Winnie. 'STOP!' But it was too late. The dustman couldn't hear her. He jumped into his truck and drove away.

'What shall I do?' cried Winnie.

Then another truck came through the gate.
'My new wand!' said Winnie. 'It's arrived! Thank goodness!'

She grabbed the new wand, waved it once, and shouted,

ABRACA

The book of spells flew out of the rubbish truck, up into the air . . .

DABRA!

. . . and dropped into her arms.

Winnie rushed inside, and looked up the spell to make things come back.
Then she shut her eyes, waved her wand four times, and shouted,

ABRACADABRA!

The computer and Wilbur came back.
'Oh, Wilbur!' said Winnie. 'You're bright blue!
Whatever happened?
Never mind, I'll change you back to black again.'

She went to the computer
and clicked the mouse.
Wilbur was a black cat again.

'Good,' said Winnie.
'It still works. But I think I'll keep my
book of spells and my magic wand.
I might need them one day.'

One Snowy Night

M Christina Butler

illustrated by Tina Macnaughton

Little Tiger Press
London

The cold wind woke Little Hedgehog
from his deep winter sleep. It blew his
blanket of leaves high into the air,
and he shivered in the snow. He tried
to sleep again, but he was far too cold.

Suddenly, something fell from the sky . . .

For Tony, with love
_MCB

For Ella + Alan
_TM

LITTLE TIGER PRESS
An imprint of Magi Publications
1 The Coda Centre, 189 Munster Road, London SW6 6AW
www.littletigerpress.com

First published in Great Britain 2004

Printed in China
4 6 8 10 9 7 5 3

...BUMP!

It landed right in front of his nose.
It was a parcel, and it had his name on it.

To Little Hedgehog
With Love From
Father Christmas xx

Little Hedgehog opened
the parcel as fast as he
could. Inside was a red
woolly bobble hat . . .
hedgehog size!

He put it on at once.
He pulled it to the back.
He pulled it to the front.
He pulled it to one side,
then the other . . .

But no matter how he stretched it
to fit, his prickles got in the way *every time*.
By now the hat was far too big for a
little hedgehog.

He took it off and gazed at it,
until at last he had an idea . . .

He gave the hat a shake
and wrapped it up again.
He tore a bit off the label
and wrote on the rest.

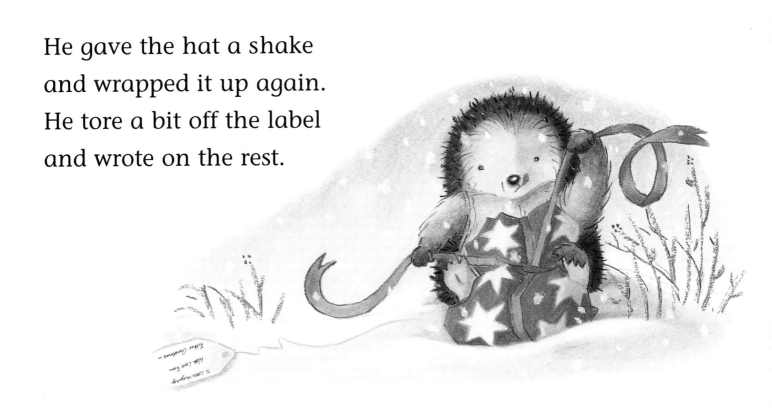

Then off he ran to Rabbit's house.
Rabbit was out, so he left the present
on his doorstep.

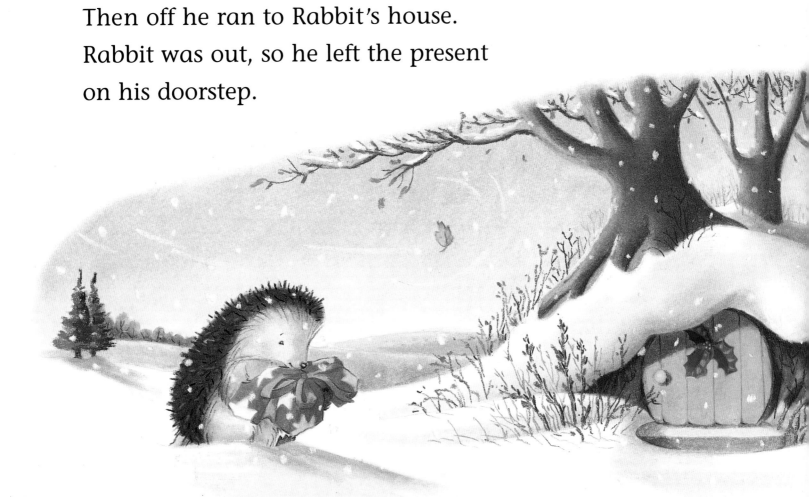

It was snowing hard as
Little Hedgehog tried to find his
way back home. The snowflakes flew
all around, and he wasn't sure which
way to go.

 "Oh dear, oh dear," he said as he pattered
to and fro. "I shouldn't have come out
in this weather. But I'm sure Rabbit
will be pleased to have a nice
woolly hat to wear."

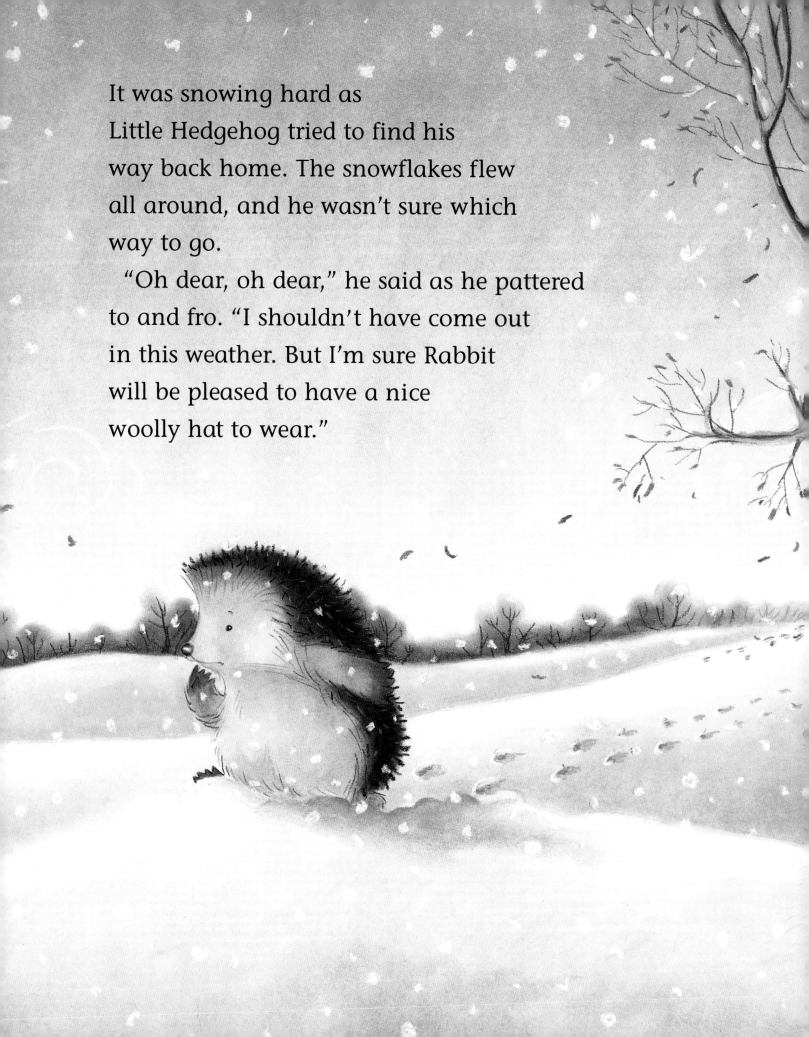

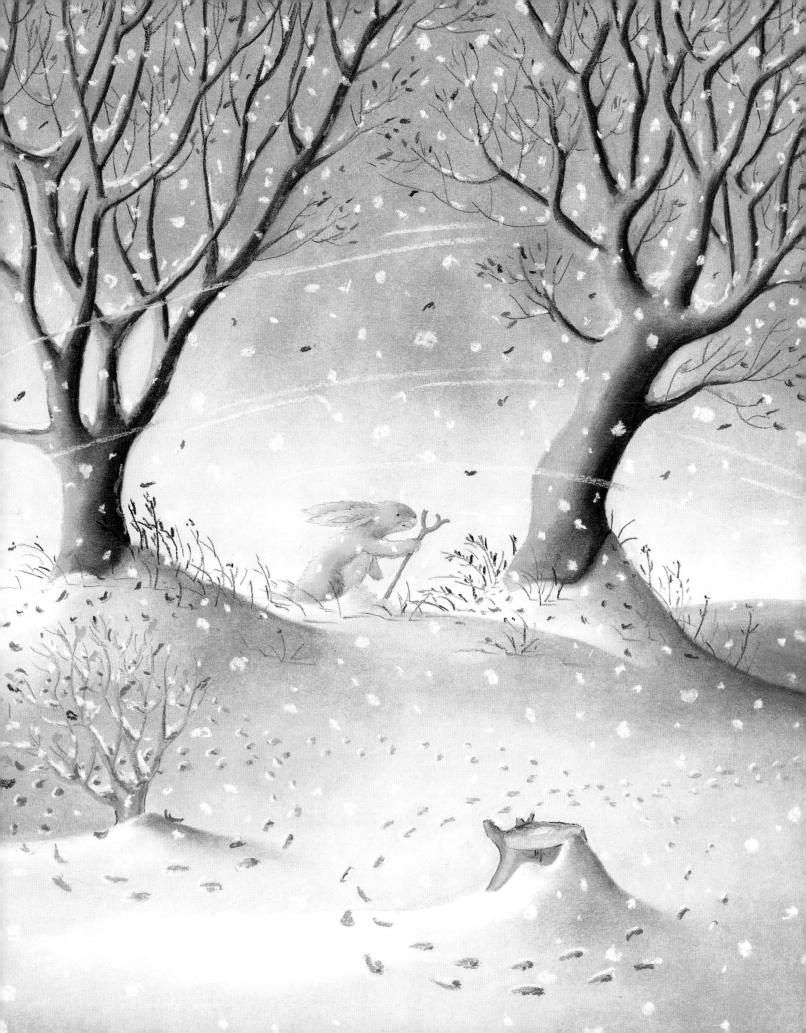

"Bother the snow!" said Rabbit,
rushing home. He spotted the parcel
lying on his doorstep.
"What's this?" he squeaked with delight,
ripping off the paper. "A bobble hat,"
he cried. "For ME!"

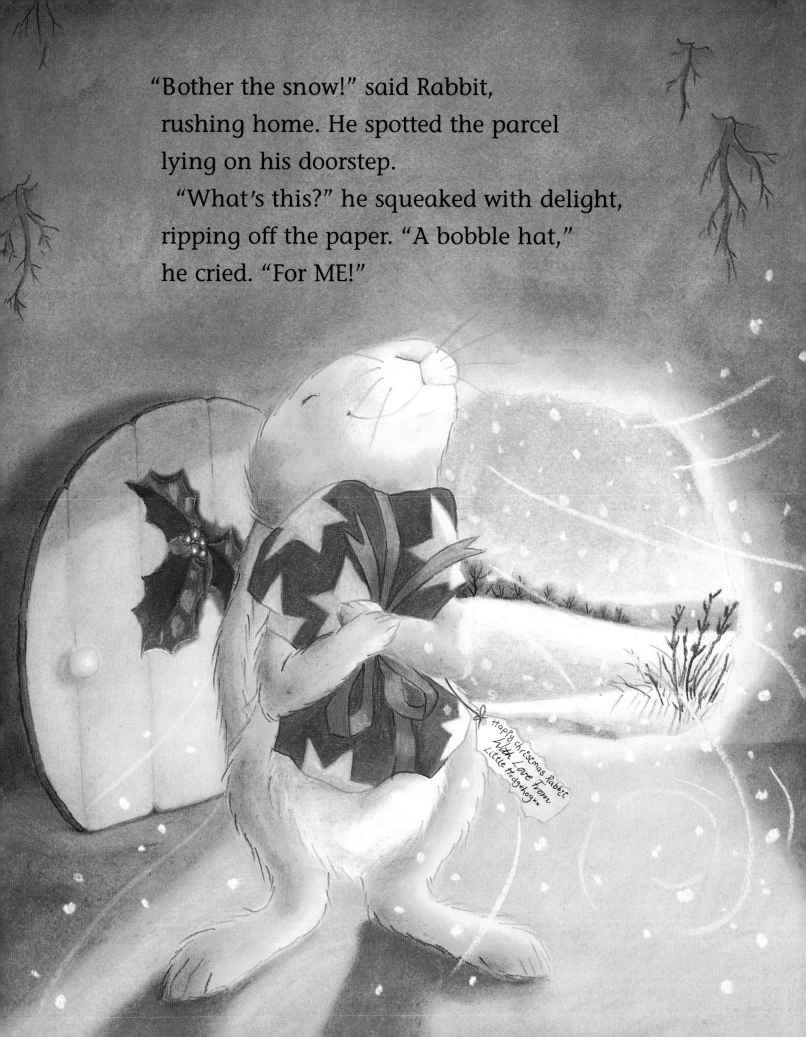

Happy Christmas Rabbit
With Love From
Little Hedgehog xx

He put it on at once. He tried it with
his ears inside, and then outside.
He pulled it this way and
he pulled it that way.
But no matter how
he stretched it to fit,
his ears got in
the way . . .
every time!

By now the hat was
very much bigger. It was
far too big for a rabbit.
So . . .

. . . Rabbit wrapped up the hat once again,
and wrote on a corner of the label.
Then off he went to Badger's house.

The cold weather made Badger very
grumpy.
 "Happy Christmas, Badger!"
shouted Rabbit.
 "Who's there?" growled Badger.
 "Happy Christmas!" repeated Rabbit,
giving him the parcel.

"A Christmas present?"
said Badger.
"For ME?"

Badger put the hat on.
He pulled it down over his ears.
 "What . . . about . . . THAT!"
he said, looking in the mirror.
 "Very nice," said Rabbit.
 "What did you say?" said Badger.
 "*Very nice!*" yelled Rabbit,
hopping off.

"Don't you like it?" asked
Badger, turning round.
But Rabbit had gone.
 Badger took the hat off.
"This is no good to me,"
he said. "I can't hear
a thing. What a pity.
It's such a nice colour."

So Badger wrapped up
the parcel and marched
off to Fox's house.
He didn't bother
with a label.

Fox was going out exploring.

"Here you are, friend," said Badger merrily.

"A Christmas present, especially for you!"

"Christmas?" snapped Fox, puzzled.

"Yes, Christmas!" called Badger.

"Time to be nice to each other!"

And he plodded off.

"A hat?" sneered Fox, opening the parcel. "What do I want with a hat?"

Then he looked at the hat again . . .

He made two holes for his ears and put it on. Satisfied, he went on his way.

The white fields twinkled in the
moonlight. Fox sniffed around and
found a small trail. He followed it this way
and that way until suddenly it stopped.
There was something under the snow!

Fox began to dig and dig,
until he found a small hedgehog.
It was cold and did not move.
"Poor little fellow," said Fox.
He put the hedgehog inside the
red woolly hat and carried
it to Rabbit's house.

Rabbit and Badger were having supper.
"Look what I've found in the snow!"
cried Fox, bursting in.
They all looked into
the hat.

"A hedgehog?" said Badger.
"What's a hedgehog doing out at
Christmas time? He should be fast asleep!"
"It's my friend Little Hedgehog!" cried
Rabbit. "He must have got lost going
home in the snow!"
Little Hedgehog opened his eyes.
"Hello," he said sleepily. "Oh, this
is such a lovely warm blanket."

The friends all looked at each other.
Rabbit grinned and Fox scratched his head.
 "Hmmm," said Badger. "I think this woolly
hat is *just right* for Little Hedgehog!"
 "Happy Christmas, Little Hedgehog!"
they all cried . . . but Little Hedgehog
was fast asleep!